Washington

Scenes from a Capital City

For Laura B.

◆

For Gabriella

Washington

Scenes from a Capital City

By **JOHN CLEAVE** *Introductions by* **BENJAMIN FORGEY**

edm EDITIONS DIDIER MILLET

ILLUSTRATOR'S ACKNOWLEDGEMENTS

Washington is the place that I have called home longer than any other. It has been changing constantly ever since I arrived here to live in 1970, with some sad losses but also with many improvements. It is a wonderful city of many parts, and one of the joys of being a photographer here has been the incentive to explore the familiar and the unfamiliar. Some of both are to be found in this book.

My thanks are due, first, to Didier Millet and Charles Orwin, owner and General Manager of Editions Didier Millet, who gave me time to show my early renderings and had the faith to encourage me to continue; to my editor, Shan Wolody, whose e-mails from Singapore have cheered my mornings as she and her design team have patiently brought the book to a harmonious whole; and to Chip Akridge, Chairman of Akridge, and Michael Stevens, President and CEO of the Washington DC Marketing Center, whose support made the book possible.

My thanks, also, to Benjamin Forgey for his text: a superb balance of fact, anecdote and passion about a city he knows and loves so well. The matchless ease and professionalism of Ben's writing was why he was, for me, the only choice for a writer.

Last, but by no means least, I owe an enormous debt to my wife, Laura. Without her there would have been no "Washington". It was her idea that I turn my computer-manipulated photographs into a book, and she who introduced me to the works of our publisher. For two years since then she has constantly encouraged and supported the work and been my most discerning critic. Thank you, Lauramou. This is for you.

John Cleave

The publishers gratefully acknowledge the generous support of the sponsors to the first edition

Illustrations
Endpapers: Washington Navy Yard gateway by Benjamin Latrobe.
p. 1: A terracotta frieze encircling the National Building Museum depicts the Civil War.
p. 2: A fountain in the gardens of Dumbarton Oaks.
p. 5: Clark Mills' statue of George Washington as a young Lieutenant, inaugurated in 1860, stands on Pennsylvania Avenue, NW, at Washington Circle.

Illustrations, captions and gazetteer © John Cleave
Introductory texts © Benjamin Forgey
Design and typography © Editions Didier Millet 2003

Editions Didier Millet
121 Telok Ayer Street, #03-01
Singapore 068590

www.edmbooks.com

First published in 2003, reprinted in 2004
The revised and updated edition published in 2007
Reprinted in 2015

Editorial Director: Timothy Auger
Editor: Shan Wolody
Designer: Tan Seok Lui
Production Manager: Sin Kam Cheong

Printed in Singapore by Tien Wah Press

ISBN 978-981-4217-48-4

Contents

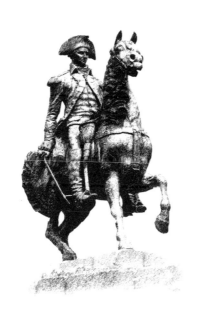

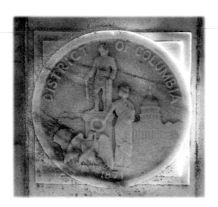

Historic Washington

Among American cities, Washington is an anomaly. Typically, a town grows up around a port, roadway junction or railroad crossing and then, if chance bestows a smile, town turns into prosperous city. Washington, on the other hand, was created with one goal clearly in mind—to establish a political capital for fractious former colonies trying desperately to maintain a bond of union.

Generally speaking, urban skylines in the United States celebrate commerce with clusters of shining office towers, but Washington keeps by law a relentlessly low profile. The city's skyline is pierced, it's true, by two powerful structures, but that's the whole point. These structures—a towering stone obelisk and a monumental cast-iron dome—are inescapable. As you move about the city they seem to follow, disappearing and then reappearing insistently, lest you forget where you are and why that place exists.

Symbolism is even written into the capital's 200-year-old ground plan. Where the streets and buildings of most cities obey the repeat rhythms of the grid, Washington's layout is a calculated jumble of acute and obtuse angles. Diagonal boulevards, named for the states that make up the union, slice through the orthogonal grid.

Furthermore, most of the vistas created by these broad streets terminate in a statue, monument or memorial that carries historical meaning. In both two and three dimensions, then, the whole artful composition episodically spells out a compelling national narrative.

The city also is unique in a perverse way. In the rush to live up to their new Constitution and tend to other pressing matters, the founding fathers of the democracy somehow forgot to provide for the voting rights of residents of the capital city. As a result Washingtonians, unlike citizens of the 50 states, have not a single voting representative in Congress. (They can, however, vote in presidential elections, and elect a mayor and city council.)

Oh, and have I mentioned that the city is absolutely gorgeous? Many American cities have their distinctive charms, I suppose, but Washington (in my unprejudiced view) is beyond compare. "Potomac fever" is a phrase customarily used to describe politicians in heat for power, but it also applies to ordinary citizens, be they residents or visitors, who become captivated by the resonant beauty of the place. This happens all the time, and it can take you unaware.

You can be sitting, say, on the steps of the Lincoln Memorial when the sun emerges suddenly to light up the striking obelisk of the Washington

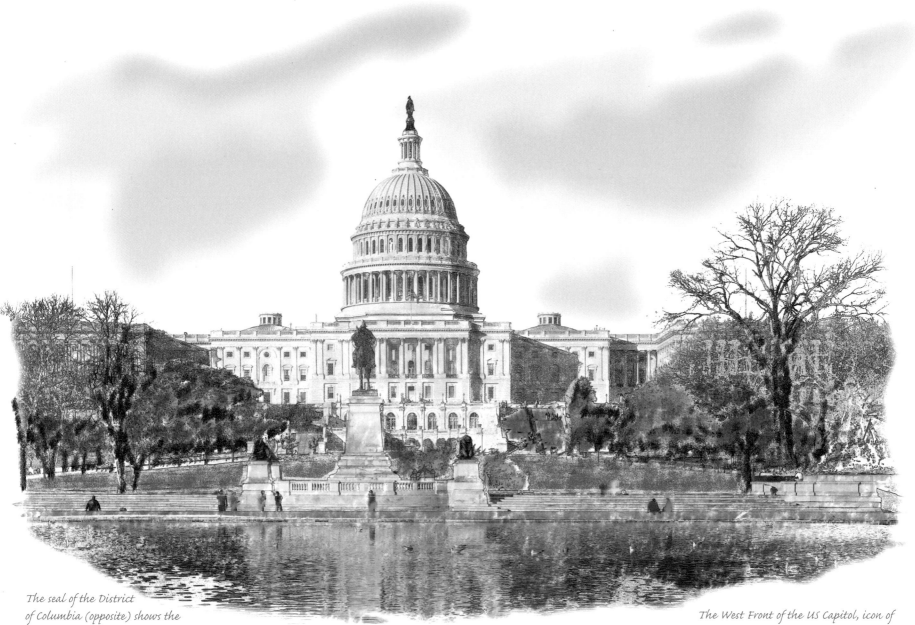

The seal of the District
of Columbia (opposite) shows the
Capitol building, the American eagle, the figure of Justice,
and George Washington. The seal and a motto, "Justitia
Omnibus" (Justice for All), were adopted on 1 June 1871.

The West Front of the US Capitol, icon of
Washington, overlooks the Mall. The Grant monument and its
reflecting pool are in the foreground. Congress moved to Washington from Philadelphia in
1800 and took up residence in the Capitol while it was still under construction.

Monument and the powerful dome of the Capitol, two miles distant in the east, yet etched against the sky with sublime clarity. You'll be pardoned if, unexpectedly, you feel a shiver in the spine, a lump in the throat.

Once, I flew into National Airport on a plane filled with French passengers, transfers in Boston from a Paris flight. It was a perfect summer evening, the sun setting to our right as the pilot, observing the strict safety rules of the Federal Aviation Administration, followed the course of the winding river on his approach from the north. All was quiet as the city began to lay itself out for us below the window on the left side of the fuselage. But when the grand view snapped momentarily into place—Lincoln Memorial in the foreground, then the long allee of water and grass connecting it to the obelisk and the dome—just then, the plane erupted with spontaneous applause and shouts of "Bravo!"

For the other passengers, it was a memorable end to a long journey. For a seasoned Washingtonian, it was an unforgettable instance of Potomac fever, sneaking up to snatch you by surprise.

Of course, the city has its low-key charms, as well. That allee, known simply as the Mall, is a place of history and commanding formality, but it's also a playground—you'll find people flying kites there, or playing softball, or walking babies and dogs, unconcerned with the Seriousness all around.

Yet when people do get seriously concerned, they again flock to the Mall—it's where in 1963, to cite one memorable instance, the Reverend Martin Luther King Jr. delivered his ringing "I Have a Dream" speech.

Washington is an international city—and in this, clearly, it is not alone. But the presence of the many foreign embassies and large, important institutions such as the World Bank, the Organization of American States and many others does lend a high tone to the capital's internationalism. An assiduous listener might count up to a half-dozen languages just by letting crowds flow by during an intermission on the enchanting terrace of the John F. Kennedy Center for the Performing Arts, overlooking the Potomac River. This international flavor effects Washington's neighborhoods—the Woodrow Wilson public high school in northwest Washington counts pupils from more than 75 nations among its student body.

The city's cultural life is vital and varied. With three major performance halls accommodating opera, symphony orchestras and large-scale theatrical productions, the Kennedy Center is the centerpiece of high culture in the performing arts. The splendid museums lining both sides of the Mall and scattered through the city perform the same high-end functions in the visual arts. These facilities are supplemented by an array of classical music venues, jazz clubs, art galleries and repertory and experimental theaters. One can spend a rewarding day trooping from gallery to gallery in Georgetown and along R Street in Dupont Circle, and many a worthwhile evening at the string of theaters on 14th Street, Washington's "off-Broadway."

Underneath its intensely political surface, Washington pauses for quieter pursuits. The city's greenness contributes to an air of relaxation. The abstract painter Sam Gilliam, when asked why he chose

Washington over New York as a place to work and raise a family back in the 1960s—no idle choice for an ambitious artist—replied simply, "It's the trees." Gilliam spoke for many. But with equal justification, he might have said, "It's the light." There are perhaps a dozen days in a year when the luminous atmosphere of the riverside city magically transforms everything it touches. Scant wonder, then, that when the city did produce a group of artists worthy of international renown, it was known as the Washington Color School, made up of abstract painters whose canvases shimmer with luminous color and light.

Classical architecture reacts wonderfully to the Washington light, reflecting the brilliance from long walls of limestone or marble, and catching shadows in subtle entablatures. The examples of Athenian Greece and republican Rome exerted a profound influence on the city's founders and its first architects, who believed in evoking these ancient precedents to assert the authority of a new democratic regime. Evoking is the word, not copying. Benjamin Henry Latrobe exemplified this cast of mind when he created the famous corncob capital to terminate classically proportioned columns in the Capitol.

The classical spirit exerted its hold on the city well into the twentieth century. When architect John Russell Pope's superb temple for the National Gallery of Art went up in the early 1940s it was called, by its detractors, "the last of the Romans." Yet tasteful classicism again prevailed when James Ingo Freed designed the Ronald Reagan Building and International Trade Center on Pennsylvania Avenue in the 1990s. But there were always exceptions—the Smithsonian Castle, the towering spire of Georgetown University's Healy Hall, the Gothic towers of the Washington National Cathedral on the heights above Georgetown, and many others.

The beautiful Washington National Cathedral, completed in 1990, has been described as the last Gothic cathedral. The steps up to the tranquil Women's Porch, designed by Bostonian architect Philip Frohman, are on the north side.

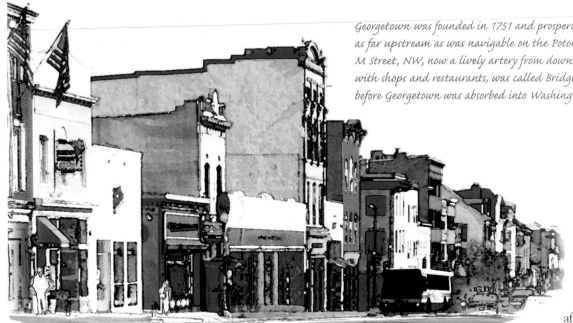

Georgetown was founded in 1751 and prospered as a port as far upstream as was navigable on the Potomac River. M Street, NW, now a lively artery from downtown, lined with shops and restaurants, was called Bridge Street before Georgetown was absorbed into Washington in 1871.

In this respect, two events of the 1970s are worthy of note. The saving of the Richardsonian Romanesque Old Post Office building, for years considered an offending monstrosity amidst the classic revival pomp of the Federal Triangle on the south side of Pennsylvania Avenue, heralded the coming of age of the city's historic preservation movement, now one of the country's most vigorous. And the year 1978 saw the completion of I. M. Pei's triangulated National Gallery East Building, an elegant modernist riposte to Pope's Roman masterpiece, which is now called, simply, the West Building.

Nor are Washington's residential neighborhoods classical redoubts either in style or in ambiance. For the most part, rather, they are pleasantly unceremonious, from the tightly (and charmingly) packed streets of Georgetown in the west to the rambling informality of Brookland in the northeast. "There are two Washingtons," observed journalist Benjamin McKelway in the 1950s, "political Washington and the real Washington, made up of friends and neighbors."

Georgetown set the early standard—like Boston and Philadelphia the capital by and large adopted the English pattern of connected residential

rows in its early development. Washington became a city of row houses. The city's founders were mightily concerned to see urban rows go up, built of brick rather than wood, and a few of these remain— notably Wheat Row on Fourth Street in the southwest and two fine houses at 30th and M Streets in Georgetown. The row-house pattern continued in neighborhood after neighborhood through much of the nineteenth and twentieth centuries.

Then again, Washington also is a city of elegant freestanding mansions and of multi-story apartment buildings. Perhaps the best example of the former—one of many, to be sure—is the stretch of Massachusetts Avenue extending from midtown up the western hills to 34th Street. Skilled architects made their careers designing fashionable houses on and behind this avenue for the families of wealthy industrialists who came to the capital for its fall and winter social season in the late nineteenth and early twentieth centuries. When these folks abandoned their mansions— even the very rich could hardly afford the upkeep—Washington, unlike many other cities with similar "grand boulevards," was fortunate to have a ready-made clientele for the architecture. Foreign governments snapped up the mansions and converted them to embassies as the city grew in international status after World Wars I and II.

Washington's lovely apartment buildings come in many shapes, sizes and styles, and are liberally peppered throughout the city. But Connecticut Avenue remains nonpareil. If 16th Street is "the street of churches," from Latrobe's St. John's Church at Lafayette Square all the

way out to the Maryland line, Connecticut is the avenue of splendid apartment buildings. The parade starts with several notably quixotic structures behind the equestrian statue of imperious Union General George McClellan on the hill above Dupont Circle, and continues with a string of delights for several miles—there is the commanding Dresden, the Italianate Woodward, the robust Wardman Park (now a hotel), the stylish Kennedy-Warren, the spacious Broadmoor, the post-modern Saratoga, and on and on. Developed by a private company early in the twentieth century to make way for a trolley line carrying customers out to its excellent freestanding homes in Chevy Chase, the avenue, with only an occasional slip-up, is an urbanistic triumph.

One of the city's earlier and more significant streetcar suburbs is the small community of LeDroit Park, a quiet retreat nestled just beyond the original Boundary Street (now Florida Avenue), conceived in the 1870s as a "romantic suburb." What is significant about LeDroit Park, aside from its considerable architectural charms, is its social history. It was designed to appeal to middle-class white families and, as was the custom (and the law) at the time, African Americans were excluded. (Being the capital of a democracy did not prevent Washington from following rigidly exclusive racial practices; selling and owning slaves was common in the city up to the Civil War, and segregation was not outlawed until the 1950s.)

Yet LeDroit Park abutted Howard University, the notable institution founded after the Civil War that became a towering force for advanced education of African Americans. The original inhabitants even erected a high fence to prevent blacks from passing through, but the barrier finally came down in 1891. The "fence war," as it was called, symbolized the racial antagonisms that continued to plague the city, but the

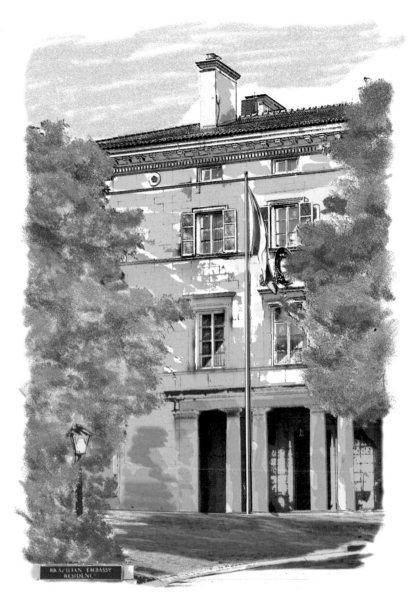

McCormick House on Massachusetts Avenue is now the residence of the Brazilian Ambassador to the USA. The style of John Russell Pope's 1912 classic owes much to 16th-century Roman palaces.

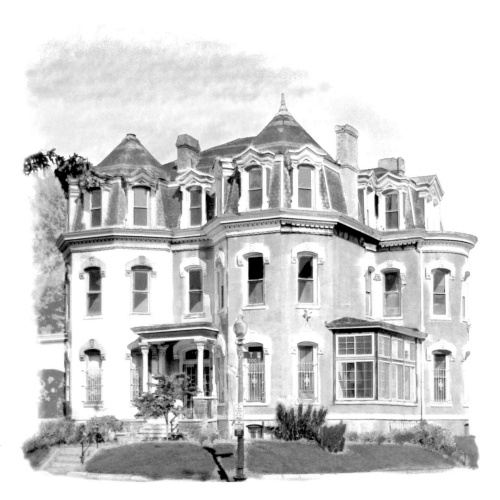

When first developed about 1870 LeDroit Park was on the outskirts of the city. This house on the circle at Third and T Streets, NW, is typical of early styles. It originally belonged to Civil War General William Birney.

transformation of the neighborhood from a middle-class white to a middle-class black enclave early in the twentieth century testified to the increasing significance of the role of African Americans in Washington's professional and cultural life, which continues to this day. There are more African American architects in this city of some 570,000 people, for instance, than in all but two of the 50 states.

When Sam Gilliam spoke of the lure of Washington's trees, he was referring to leafy neighborhoods such as LeDroit Park. But Washington's principal green adornment indubitably is Rock Creek Park, although the word "park" is misleading. Encompassing 1,754 acres and a mile wide in its upper reaches, Rock Creek Park is pretty much a true urban forest, with steep gorges and thick-growth deciduous trees following the meandering stream as it courses toward the Potomac. It was set aside by Congress in 1890, a time when that body was creating national wilderness parks in the American West.

It is thus possible in Washington to trudge to a point in these deep woods where only birds, squirrels and the occasional deer interrupt the stillness. A walk in Rock Creek Park can turn into a trip back to the region's pre-colonial past. Henry Fleet, a young English adventurer and one of the first white men to set foot on the land that became Washington, recorded his impressions in 1632: "The place without question is the most pleasant and healthful place in all this country.... It aboundeth in all manner of fish. The Indians one night commonly will catch thirty sturgeon in a place where the [Potomac] river is not twelve fathoms broad. And as for deer, buffaloes, bears, turkey, the woods do swarm with them, and the soil is exceedingly fertile."

Washington has a way of always luring you back, eventually, to its beginnings. And for the city itself, "beginnings" always means

Pennsylvania Avenue and the Mall. Benjamin McKelway's words about neighborhoods, for instance, merited being engraved in the honed granite surface of Freedom Plaza, an open quadrangle in the middle of a downtown segment of Pennsylvania Avenue. Another 40 or so thoughts about Washington by famous and scarcely known observers are set inscribed at your feet. "One of these days this will be a very great city, if nothing happens to it," quipped novelist-historian (and descendant of two presidents) Henry Adams in 1872. Reading the sayings is a bit like eating popcorn, in that it is hard to stop once you've started. You traipse around the plaza, looking always downward.

But when you pause to take in the larger picture, you discover that the pattern of the plaza paving is that of a map, and that the map underfoot is none other than the central portion of the original plan for the city, conceived in five months of brilliant labor by Major Pierre Charles L'Enfant back in 1791. To pave the plaza with L'Enfant's handiwork was the twentieth-century inspiration of American architect Robert Venturi, a wise and witty man who foresaw the exhilarating advantage of being able to stand upon a plan of the city and stand in the plan's outcome—the real city of Washington. In effect, he created a platform from which to begin appreciating L'Enfant's great vision.

George Washington and Pierre L'Enfant made an extraordinary team. Washington, of course, was the new nation's first president and Revolutionary War leader—the indispensable man in the formation of what he referred to as "the last great experiment for promoting human happiness." L'Enfant was one of that legion of European notables who

came to the aid of the American colonies in their military struggle for independence—and the only one, as it turned out, classically trained in the visual arts. He spent part of his childhood in Versailles, site of the fabulous Baroque composition laid out by landscape architect Andre Le Notre for Louis XIV in the seventeenth century, and for several years before departing for America, at age 22, he attended the Royal Academy of Painting and Sculpture.

In America, the unique talents of the young officer, who was assigned to the engineer corps, caught General Washington's eye. The two met on but a half-dozen occasions—a total of perhaps a half-day's time—yet they thought on the same ambitious, Enlightenment wavelengths. When the time came to design a new capital city for the young republic, President Washington turned unhesitatingly to the Frenchman for assistance.

The location of the new city was dear to Washington's heart and his ambitions for commercial expansion of the new nation—a flatland of marshes and farms ringed by hills, about a dozen miles north of his beloved estate, Mount Vernon. There were two existing towns, Alexandria, Virginia, and Georgetown, Maryland, each with good harbors on the Potomac. And, most important, the site was in the geographic middle of the former colonies, and thus mitigated the already brewing sectional conflict between North and South.

Washington chose the spot, but only after a political compromise attained by Thomas Jefferson and Alexander Hamilton (whose own personal and political conflict was already brewing, too) paved the way. Hamilton and the North would accept the southerly location, the pair

agreed, if Jefferson would round up sufficient Southern votes to support the assumption of state war debts by the new national government. A law was passed by Congress ratifying the deal and giving the president the authority to select a district 10 miles square, the land to be donated by the states of Maryland and Virginia.

L'Enfant began his work in February 1791. By summer, he had completed the rudiments of his audacious plan. Because he misunderstood the limits on the president's power, and because he lacked any sense of the negotiating skills needed to get things done in the fledgling democracy, the proud Frenchman—who preferred the Americanized name, Peter—literally forced his patron's hand: Washington regretfully accepted his planner's resignation early in 1792. The remainder of L'Enfant's life was a rather sad, poignant affair. He died, impoverished, in 1825, without ever receiving the credit (and money) he thought was his due. But his great work had lasting effect. The key to L'Enfant's genius, observed architect Allan Greenberg in 1999, was that he "understood that the duty of the architect or city planner is to articulate not only form, but meaning."

What L'Enfant did, in essence, was to translate into democratic terms modes of planning that had been used in Europe to legitimize and glorify kings and nobles. To this highly original undertaking he brought an exemplary sensitivity to the topography of the site and a sympathetic understanding of the United States Constitution, then but four years old.

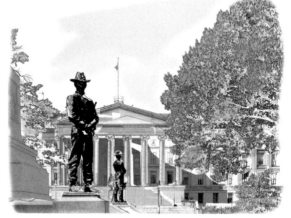

The US Treasury Building is the oldest federal department building. From the forecourt of the south portico there is a fine view up Pennsylvania Avenue to the Capitol.

With both clarity and boldness, L'Enfant's plan embodies the concept of a balance of powers between the executive and legislative branches of government.

He situated the "Congress house" at the apex of the most prominent hill, which he referred to in his notes as "a pedestal waiting for a monument." He placed the president's house and executive departments on a lesser rise, a mile to the west. He then triangulated this spacious composition by making a place for an equestrian statue of George Washington, commissioned by the Congress in 1883 (but never executed) on a line directly south of the president's mansion. The hypotenuse of this triangle was a great boulevard—today's Pennsylvania Avenue—connecting the White House and the Capitol. Linking the Capitol with the Washington statue was a parklike axial greensward—today's Mall.

There, then is the auspicious genesis. This bold triangle was the centerpiece of a street plan that, likewise, reflected both the lie of the land and the Constitution—wide diagonal avenues overlaying the customary north-south, east-west grid of streets, interconnecting to form squares and rond-points to be ornamented, in L'Enfant's view, by commemorative works "divided among the several States of the Union."

It took all of George Washington's prestige and political skill, in those early years, to ensure that this vision of a new capital stayed on course. (Nor did he demur when the

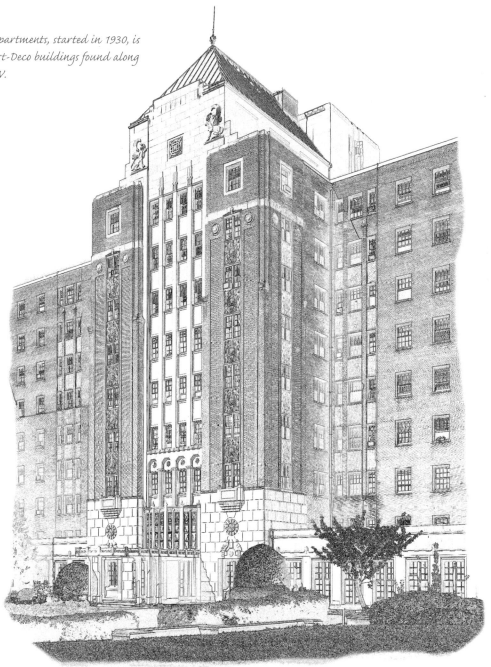

Congress decided to name the city after him—a richly deserved honor, after all.) And it took time, of course, for the city to grow into—and then out of—the noble armature conceived by L'Enfant. Charles Dickens, visiting Washington in 1842, famously observed, "It's been called the city of Magnificent Distances but it might with greater propriety be called the city of Magnificent Intentions."

Precisely so. Washington at mid-nineteenth century was a curious, unnerving mixture of muddy roads, simple wood-framed buildings, a scattering of well-built private structures and a few impressive, if widely separated, public buildings. "To make a Washington Street," a long-time resident wryly advised in the 1850s, "take one marble temple or public office, a dozen good houses of brick, and a dozen of wood, and fill in with sheds and fields." In addition to the White House and Capitol, the notable public buildings included the Treasury Department with its long Ionic colonnade, the Greek Revival Patent Office (now housing two Smithsonian museums) and the chaste, classical General Post Office (now a luxury hotel). The symbol of the city's prolonged growing pains was the Washington Monument, which stood unfinished for three decades until it finally was topped off in 1884. Cows were sometimes put to pasture in the field where it stood like a stump.

Considerable mischief was played with L'Enfant's plan during these years. The Smithsonian Institution Castle managed to violate two L'Enfant principles at once, disdaining his classicism for Gothic romance and ignoring the setbacks he prescribed for the Mall. Worse, at mid-century the Mall itself was planted as a fashionable picturesque garden, after a plan by landscape gardener Andrew Jackson Downing. It grew into a very nice public garden, indeed, but sorely lacking the symbolic clarity of the original idea. And a grave indignity was inflicted by the

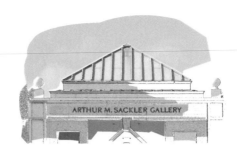

The Sackler Gallery is part of Washington's rich complex of museums owned by the Smithsonian Institution. It was founded in 1987 by Dr. Arthur M. Sackler, a New York physician, who also donated his collection of over 1,000 items of Asian art.

erection of a railroad station on the Mall's northern border, at Sixth Street. Magnificent intentions were turning to typical urban clutter.

Yet the chief event in America's, and Washington's, nineteenth-century life was, of course, the Civil War, the bitter four-year conflict that cost more American lives than any other—and that ensured the union of states would endure. Like the Washington Monument and the Capitol dome, the war is inescapable in the contemporary capital. In its symbolism Washington, very definitely, is a Union city.

Even in the depths of Rock Creek Park, the earthworks of Fort deRussy are still to be found. Standing among the tall trees, it is easy to forget that much of the primeval forest is, in fact, less than 150 years old—vast stretches of timber were cut during the war to clear firing lines for Union artillery. The fort was one of 68 defensive positions that ringed the hills surrounding the city. Nearby, on open ground at 14th Place and Van Buren Street, NW, are the remains of Fort Stevens, where President Lincoln came under fire during an attack by the Confederate army. (There's a story, possibly apocryphal, that when the tall president stood up with bullets whizzing all around, a young officer named Oliver Wendell Holmes, a future Supreme Court Justice, shouted to the commander in chief, "Get down, you fool!" If Holmes did not utter the words, somebody probably did.)

In downtown buildings there are echoes of the war. On a window frame in the Old Patent Office, which like most large Washington buildings was pressed into service as a wartime hospital, are the carved initials of a Union soldier: C. H. F., 1864, Aug. 8. The poet Walt Whitman, who tended wounded soldiers there and in 1865 attended Lincoln's second inaugural ball in the same space, compared the two experiences: "Tonight, beautiful women, perfumes, the violin's sweetness, the polka and the waltz; then the amputation, the blue face, the groan, the glassy eye of the dying, the clotted rage, the odor of wounds and blood."

Most of all, however, remains the symbolism—the significance of the war is conveyed by the Union generals on horseback that occupy center position in many of L'Enfant's special places. The names of more than 199,000 African Americans who served in the Union army, are engraved in a memorial at 10th Street and Vermont Avenue, NW. Arlington House, the Greek Revival mansion on a Virginia hill overlooking the city, was where General Robert E. Lee penned his resignation from the US Army as the war got underway—in itself a defeat for the Union, as Lee became the greatest commander of the rebel forces. The placement of Memorial Bridge, linking Lee's house (now part of Arlington National Cemetery) to the Lincoln Memorial, was conceived as a symbolic gesture reconnecting North and South.

And the most succinct and moving of the hortatory inscriptions that seem to fill every pediment and frieze in the city are those high on the wall behind the statue of the seated war president in his memorial: "In this Temple, as in the hearts of the people, for whom he saved the union, the memory of Abraham Lincoln is enshrined forever." Even Thomas U. Walter's magnificent Capitol dome is weighted with the significance of the struggle: although some argued that the iron could be put to more prudent use in the manufacture of cannon, Lincoln insisted that its construction continue. "If people see the Capitol going on," he told a White House visitor, "it is a sign we intend the Union shall go on." Thomas Crawford's bronze statue, *Freedom*, was hoisted into place atop the dome on December 3 1863.

It would take another bold, brilliant planning effort to right the wrongs done to Washington in the century since its founding. In the

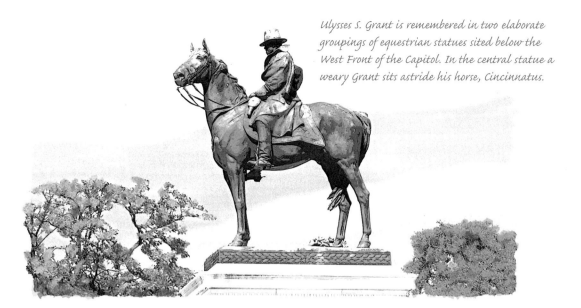

Ulysses S. Grant is remembered in two elaborate groupings of equestrian statues sited below the West Front of the Capitol. In the central statue a weary Grant sits astride his horse, Cincinnatus.

late 1890s there was a powerful, widespread reform movement to clean up the nation's increasingly dirty cities, and Washington became this movement's principal showcase. Senator James McMillan, a Michigan railroad millionaire who had caught the prevalent bug for building parks, seized the moment by creating a Senate Parks Commission for the District of Columbia.

The wisest thing McMillan did was to enlist the cream of the nation's design talent in the Washington effort: architect Daniel Burnham of Chicago, architect Charles Follen McKim of New York, and landscape architect Frederick Law Olmsted Jr. of Boston. This formidable trio, aided intermittently by sculptor Augustus Saint-Gaudens, went to work in April 1901, and by the following January had produced an astonishing array of drawings, models and words in the service of a plan to remake central Washington.

The wisest thing *these* men did was to start by studying L'Enfant's plan, which they then proceeded to resuscitate in grand fashion. The offending picturesque garden? Gone, to be replaced by a formal allee bordered by elm trees planted with military precision on the Mall's northern and southern flanks. The interfering railroad depot? Gone,

moved to a new L'Enfantesque rond-point north of the Capitol, Columbus Circle, and replaced with Burnham's colossal Union Station, modeled after the Roman Baths of Diocletian. The unsightly marshes at the eastern end of the Mall? Gone, to be filled in and then adorned with an overdue memorial to Abraham Lincoln.

Not everything the McMillan commissioners conceived actually got done, and in some respects this is fortunate. They proposed, for instance, to eradicate most of the nineteenth-century buildings surrounding Lafayette Square, but happily this did not happen. However, much of what was truly visionary in their plan did get built in the ensuing half-century or so. It is fair to say that beautiful, meaningful Washington owes almost as much to them as it does to Pierre—or Peter—L'Enfant.

For a last, or a first, view of Washington, then, nothing could be more fitting than a visit to the major's grave in Arlington National Cemetery. It was the McMillan commissioners, in essence, who put him there, for it was they who revived respect for his accomplishment. In 1908, L'Enfant's actual bones were transferred from an obscure Maryland cemetery to a site high on a hill, from which one enjoys an exceptional panorama of the city he dared to envision.

Corridor of Power

Design and construction of the Capitol and White House, seats of the legislative and executive branches of the federal government, was a chief order of business for Washington's founders. There was a nervous-making deadline—1800 was the non-breakable date for the transfer of the young government from its temporary residence in Philadelphia. The deadline was met, but just barely.

Abigail Adams, the first First Lady actually to live in the presidential mansion, famously complained about its huge size and inconvenience, and both the Senate and House of Representatives had to make do in the Capitol's north wing for seven years until the south wing was completed. The muddy stretch between the two buildings at the time bore no resemblance to today's formidable "corridor of power"—Pennsylvania Avenue has been a work in progress for two centuries.

The avenue's modern visage, however, began to be formed in earnest in the 1930s with the construction of the mighty Federal Triangle, a phalanx of classic revival buildings lining the south side of the wide street. The avenue's northern edge was shaped largely during the 1980s and 1990s. Pleasant Market Square (so named for historical reasons despite its semi-circular configuration), the humongous FBI headquarters, spacious Freedom Plaza, the renovated Willard Hotel and many of the tallest buildings in the city—160 feet being the maximum permitted height—are products of that ambitious building campaign.

Lafayette Square, the park directly in front of the White House, named for the Marquis de Lafayette, the Revolutionary War hero whose statue marks its southeast corner, is a quiet respite of history. But it was a near thing that it, too, did not go the way of the Federal Triangle. Only the intervention of two presidents in the 1960s—John F. Kennedy and Lyndon Baines Johnson—saved most of its fine nineteenth-century buildings.

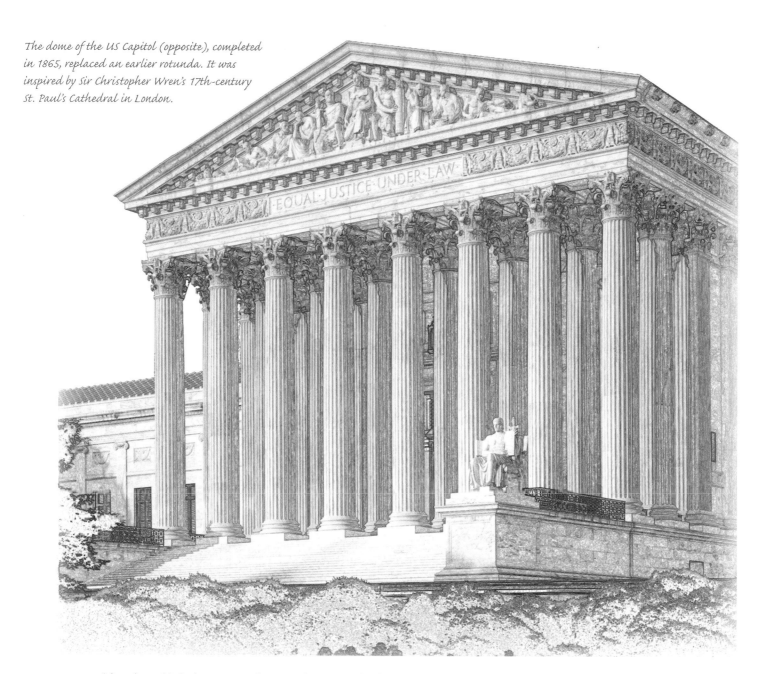

The dome of the US Capitol (opposite), completed in 1865, replaced an earlier rotunda. It was inspired by Sir Christopher Wren's 17th-century St. Paul's Cathedral in London.

EQUAL JUSTICE UNDER LAW

Although established in 1787 as the pinnacle of one of the three independent and coequal branches of government, it was not until 1935 that the Supreme Court gained its own home – this imposing building, inspired by Roman temples.

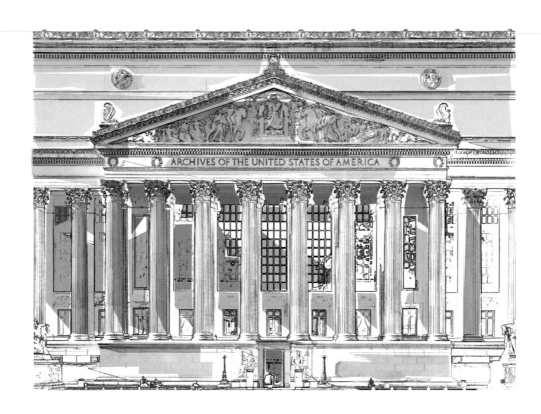

The Declaration of Independence, the Bill of Rights, and the US Constitution, are all on display in the National Archives, seen here across Pennsylvania Avenue, NW. The fine neoclassical building has been justly called the jewel of the Federal Triangle.

Heroic sculptures symbolizing the Archives' functions flank each entrance. This one bears the expression: "What is Past is Prologue."

A magnet for scholars from around the globe, the Folger Shakespeare Library on Capitol Hill houses the world's largest collection of Shakespeare's works. The fine Art-Deco building also contains a theater in which period plays are performed.

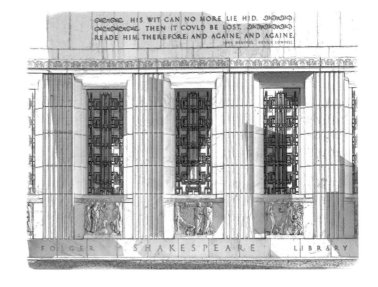

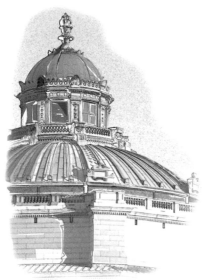

*A corner of the glorious
Great Hall of the Jefferson
Building.*

*Topped by the Torch of Learning,
the dome above the main reading
room of the Jefferson Building is a
landmark on Capitol Hill.*

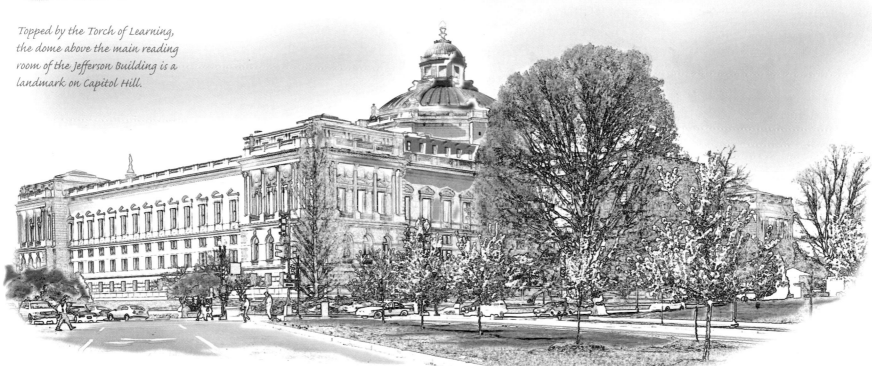

*The Jefferson Building of the Library of Congress was the first specially built to house the collection, which was started with
Thomas Jefferson's private library. It is seen here from the southeast. Today the Library of Congress, which serves as the research
arm of Congress, totals 126 million items kept on 530 miles of shelving in three buildings.*

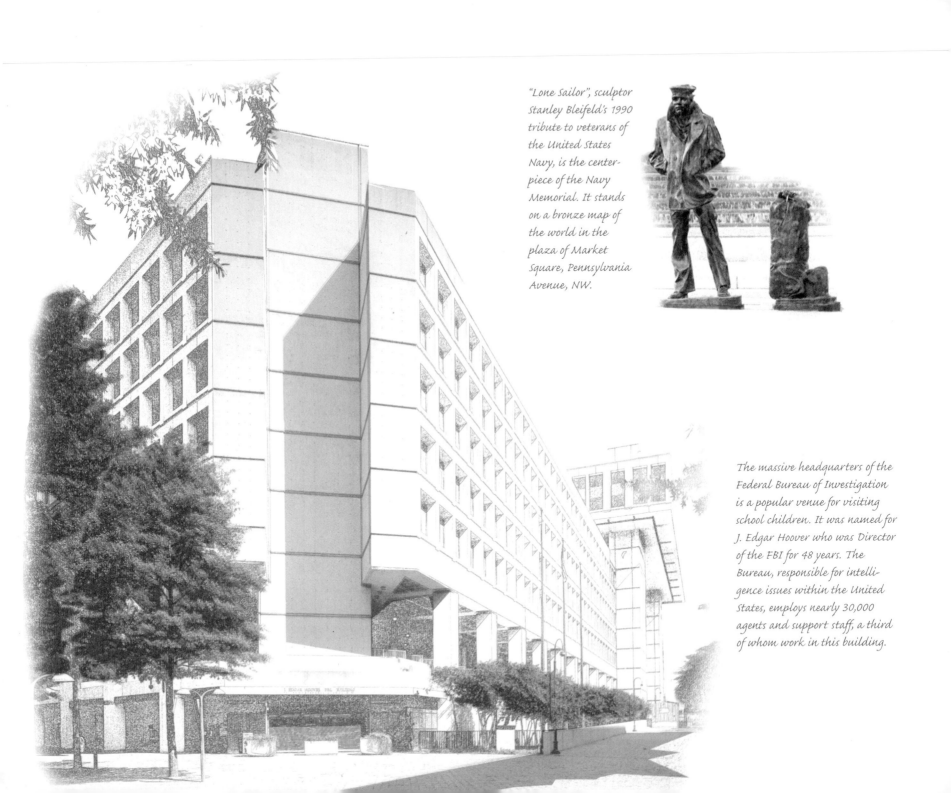

"Lone Sailor", sculptor Stanley Bleifeld's 1990 tribute to veterans of the United States Navy, is the center-piece of the Navy Memorial. It stands on a bronze map of the world in the plaza of Market Square, Pennsylvania Avenue, NW.

The massive headquarters of the Federal Bureau of Investigation is a popular venue for visiting school children. It was named for J. Edgar Hoover who was Director of the FBI for 48 years. The Bureau, responsible for intelligence issues within the United States, employs nearly 30,000 agents and support staff, a third of whom work in this building.

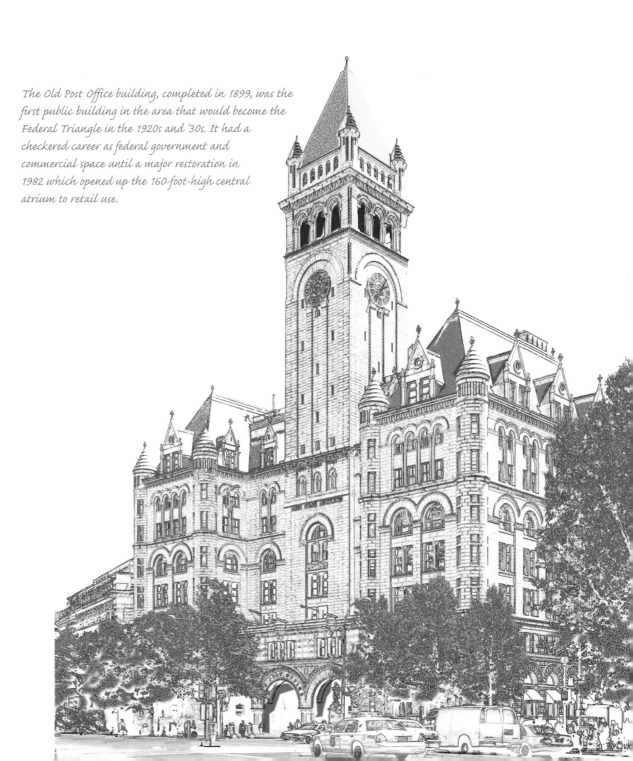

The Old Post Office building, completed in 1899, was the first public building in the area that would become the Federal Triangle in the 1920s and '30s. It had a checkered career as federal government and commercial space until a major restoration in 1982 which opened up the 160-foot-high central atrium to retail use.

Michael Lantz designed this sculpture symbolizing "Man Controlling Trade". It is one of two pieces flanking the Federal Trade Commission Building at the apex of the Federal Triangle.

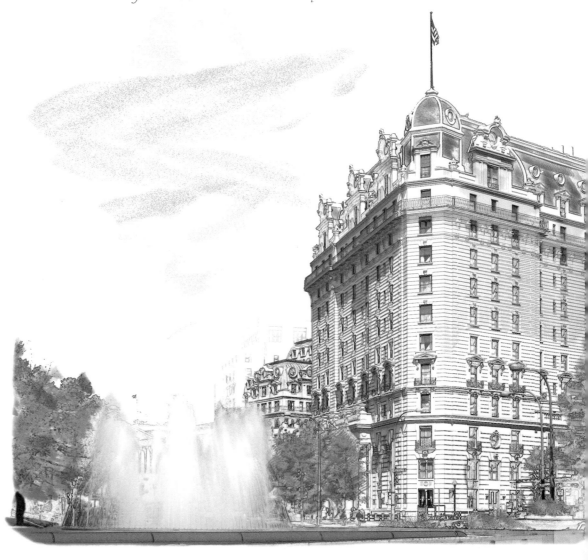

Today rated as one of the finest hotels in Washington, the Willard was named for Henry Willard, who bought a hotel on the site in 1850. Ten presidents-elect have stayed in the hotel and it has sheltered many other famous people: Julia Ward Howe wrote "The Battle Hymn of the Republic" and Martin Luther King Jr. composed his "I have a dream..." speech while staying here. Major remodeling and the addition of a new wing to create a 340-room hotel was completed in 1986.

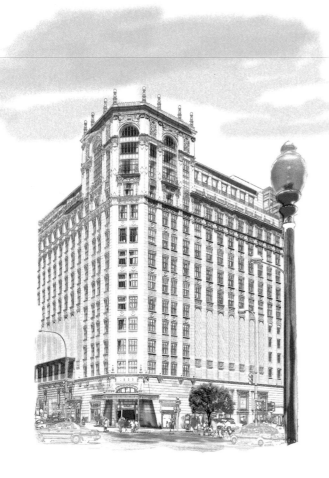

When the glittering Warner Theatre was first opened it was known as the Earle, named for a Governor of Pennsylvania, and featured vaudeville and silent movies. It had its own precision dance troupe, the Roxyettes, until after WWII when it became a movie-house only and owner Harry Warner, one of the Hollywood Warner Brothers, renamed the theater. After a period of decline in the 1970s the Warner was restored to its original grandeur, and since 1992 has featured theatrical, dance, and television presentations.

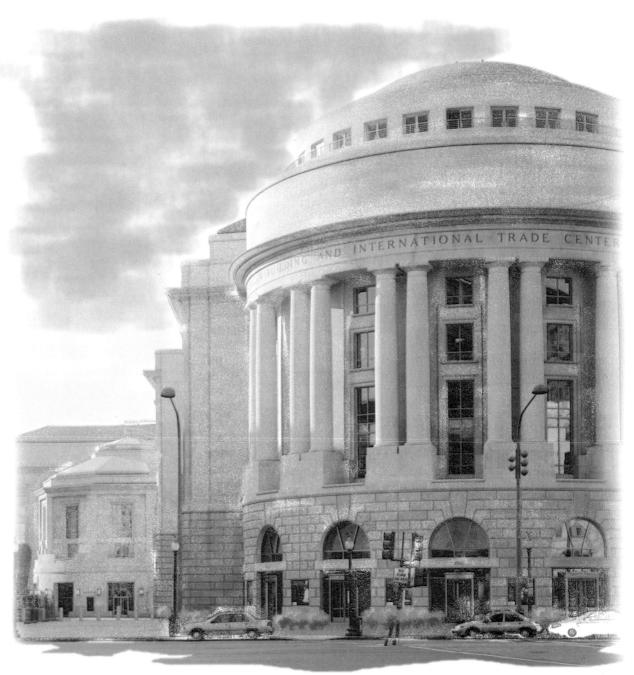

The Ronald Reagan Building and International Trade Center is the premier conference center and information resource for trade activities in the United States. Home to more than 5,000 federal employees, it is the largest government building in Washington, DC.

The grand lobby of the main entrance to the Department of Commerce on 14th Street, NW. This towering hall with its polished marble floors, pillared walls and beautifully panelled ceiling is a worthy introduction to the largest building in the Federal Triangle.

The Department of Commerce Building seen from across Constitution Avenue and 14th Street. This fine Italianate structure, sheathed in Indiana limestone, forms the short leg of the Federal Triangle. When completed in 1932 it was the largest office building in the country: its floor space covered 37 acres traversed by 8 miles of corridors which, today, maintenance staff cover on Segway® personal transporters.

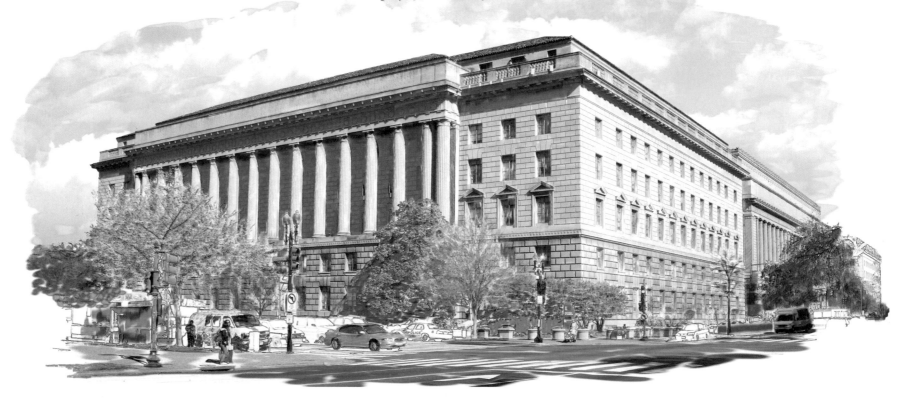

The White House has been the home of presidents since John and Abigail Adams moved into the unfinished building in 1800. The verandah on the South Portico was added by President Harry Truman during major renovations.

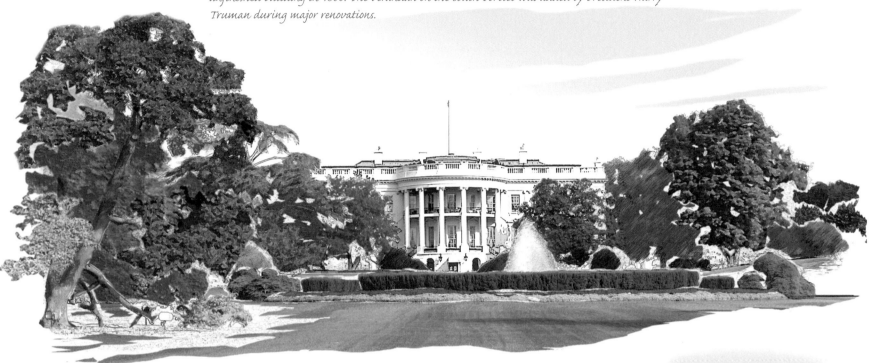

Benjamin Ogle Tayloe built this charming house on the east side of Lafayette Square for his bride in 1828. Over the 40 years he lived here Tayloe entertained a succession of presidents and his home became known as "The Little White House."

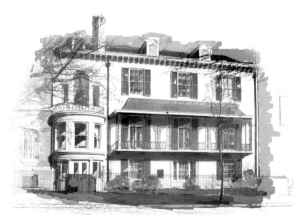

Clark Mills' bronze statue of President Andrew Jackson reviewing troops before the Battle of New Orleans dominates Lafayette Square. It was sculpted in 1853. The North Portico of the White House can be seen behind.

Lafayette Square – a seven-acre public park facing the White House – was formed from the White House grounds when President Jefferson had Pennsylvania Avenue cut through "President's Park." The Square was later named in honor of Revolutionary War hero General Marquis Gilbert de Lafayette.

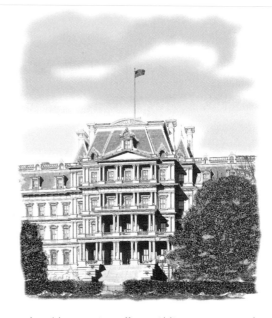

The Old Executive Office Building, more correctly now known as the Dwight D. Eisenhower Office Building, has matured as charmingly eccentric, but when completed in 1888 it was reviled and its architect committed suicide shortly after. This is the southern façade.

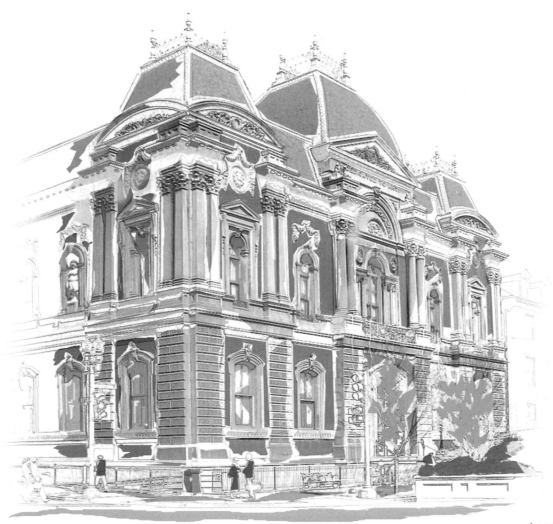

The Renwick Gallery, Washington's first public art gallery – it opened as such in 1871 – is now part of the Smithsonian Institution, and shows contemporary American crafts along with 19th-century paintings.

Commodore Stephen Decatur was at the height of his naval career when the house now named for him was built, but he lived here only 14 months before being slain in a gentlemen's duel. The main door has been restored by the National Trust to Benjamin Latrobe's original classic design.

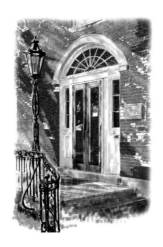

St. John's Episcopal Church, "the Church of the Presidents", across Lafayette Square from the White House, has been a place of worship for every president since James Madison. By tradition pew 54 is reserved for the current first family.

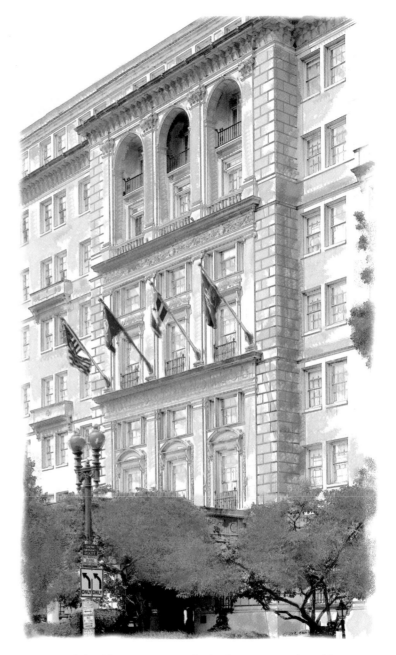

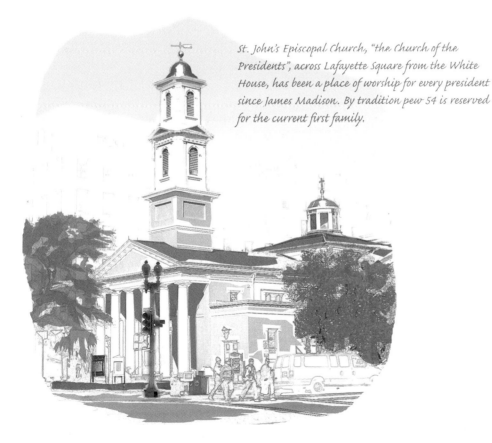

It is said that if you can't get an invitation to stay at the White House, the Hay-Adams Hotel is your next best bet. Charles Lindbergh, Amelia Earhart, Sinclair Lewis and Ethel Barrymore were all guests in the years after the hotel opened in 1928.

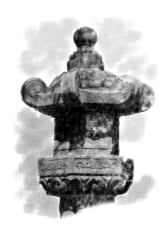

Mall, Monuments and Museums

I n his plan for the city Major L'Enfant envisaged a greensward linking the Capitol and a statue of General Washington on horseback. It would be framed on both sides, he thought, by "spacious houses and gardens, such as may accommodate foreign Ministers, etc." What actually transpired, by dint of both happy accident and foresightful planning, was a long formal green—the McMillan Commission Mall—bordered on both sides by one of the world's more astonishing assortment of museums.

The century-and-a-half splurge of museum building can trace its roots to 1829, the year an English chemist, James Smithson, bequeathed a sizable fortune to the United States government to create in its capital an institution for the "increase and diffusion of knowledge." That admirably elastic phrase led, first, to the Smithsonian Castle, completed in 1851, a red sandstone building, says architectural historian Pamela Scott, "that was planned to be, and is, the premier example of the picturesque movement in America."

Next, in 1881, came the polychrome Arts and Industries Building, and then, in 1911, the classically inspired Natural History Museum. And then… The building spree did not stop until there was simply no more room—a dozen buildings in all, notably different in architectural style, devoted to science, history and, above all, art.

Nor did L'Enfant, for all his prescience, quite envision the ultimate strength of the American urge to memorialize its presidents, statesmen, fallen soldiers and even extraordinary private citizens. Concerned Mall watchers, in recent decades, have called for a halt to memorial construction on this hallowed ground. The Mall, as it stands, is a commemorative masterpiece of the American experience.

A detail from "Social Programs", a bas-relief sculpture in the FDR memorial.

The 17th-century stone lantern (opposite) was presented to the United States by the city of Tokyo in 1954. It stands beside the Tidal Basin.

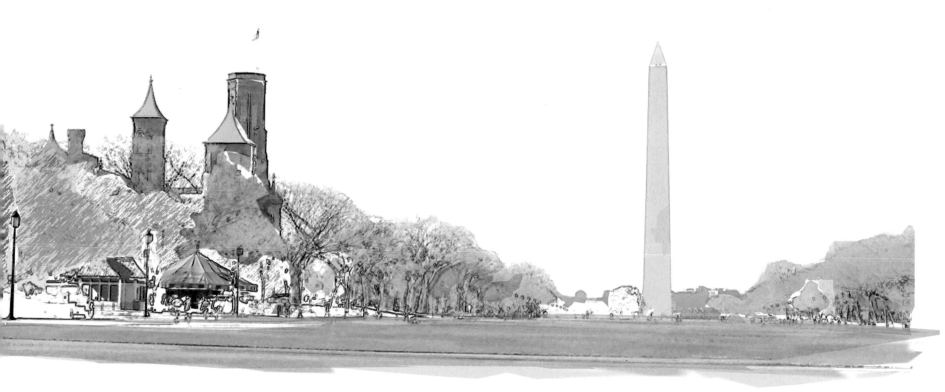

The Mall cuts a green swath through the monumental core of the nation's capital. Its two-mile sweep from the Capitol is much as L'Enfant envisioned. At the center the Washington Monument stands tall; and the sides are lined with the world's finest assembly of museums and galleries. Only the first-built of these, the Smithsonian "Castle" (on the left), intrudes discreetly into the open space.

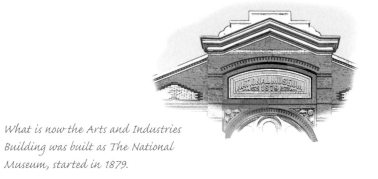

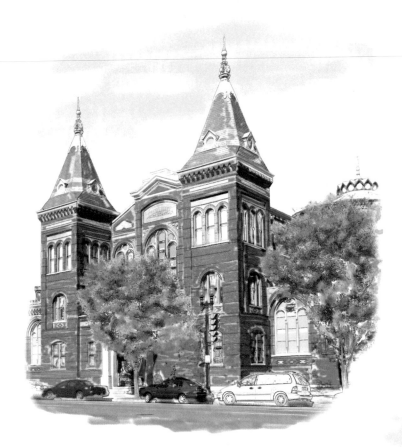

What is now the Arts and Industries
Building was built as The National
Museum, started in 1879.

The Smithsonian Building from the Enid Haupt Garden. Popularly known as
"The Castle" this red sandstone building was the first one owned by the
Smithsonian Institution. Today
it houses a visitors' center, a
restaurant, and offices.

The Arts and Industries Building, the entrance of
which is viewed from Independence Avenue, SW,
opened in 1881 in time for President Garfield's
Inaugural Ball. For many years it housed an eclectic
collection of Americana, later moved to the specialist
museums as they grew up around the Mall. After
some years of use for temporary exhibitions and
administrative offices of the Smithsonian, the exhibi-
tion halls were closed to visitors in January 2004 in
preparation for renovation. The future use of the
building has not been decided.

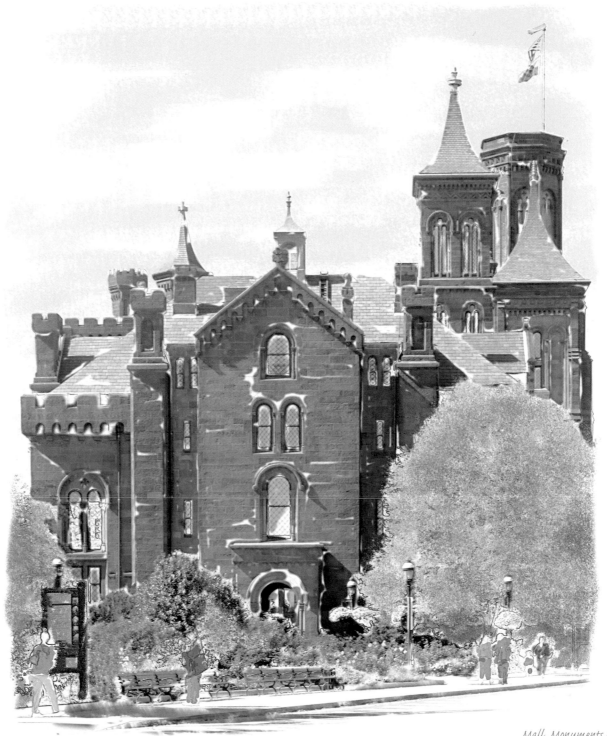

"The Castle" from Jefferson Drive. When Englishman James Smithson died in 1829 he willed his entire fortune to the United States "to found, in Washington, an establishment for the increase and diffusion of knowledge among men." The Smithsonian Institution is now the world's largest museum complex and research organization. Composed of 17 museums and galleries plus the National Zoo in the Washington area, two museums in New York City and 8 facilities elsewhere, its vast collection numbers over 142 million objects.

Opened on the country's bi-centennial, 4 July 1976, the National Air and Space Museum rapidly became the world's most popular museum. Among NASM's vast collection are vintage aircraft from the World War II era. A companion facility, the Steven F. Udvar-Hazy Center near Dulles International Airport, was opened in 2003. Its expanding collection includes the Space Shuttle "Enterprise," the Boeing B-29 "Enola Gay" and a Concorde supersonic airliner.

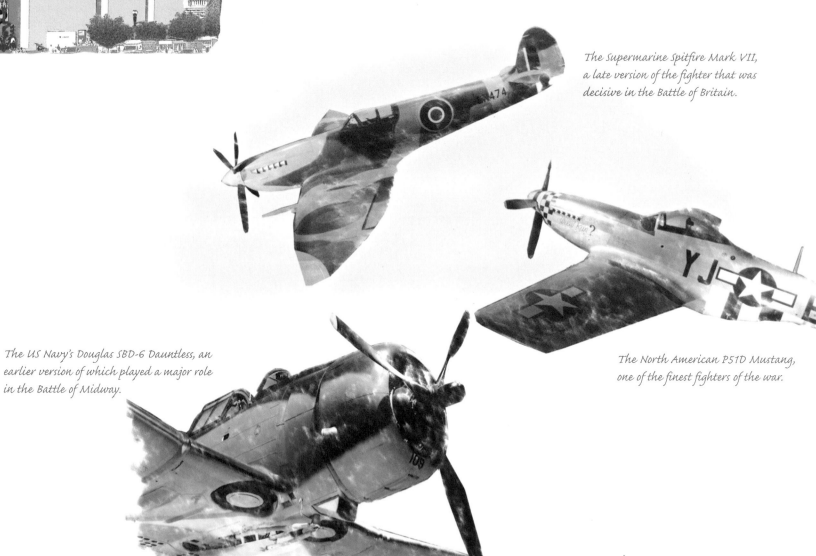

The Supermarine Spitfire Mark VII, a late version of the fighter that was decisive in the Battle of Britain.

The North American P51D Mustang, one of the finest fighters of the war.

The US Navy's Douglas SBD-6 Dauntless, an earlier version of which played a major role in the Battle of Midway.

The latest museum to be built on the Mall, the National Museum of the American Indian, was opened in September 2004 to house the 800,000 Native objects and a photographic archive assembled over 50 years by George Gustav Heye (1874–1957). The five-story building is clad in a golden-colored Kasota limestone from Minnesota designed to evoke natural rock formations. Like many Native structures the building is oriented to the four cardinal points.

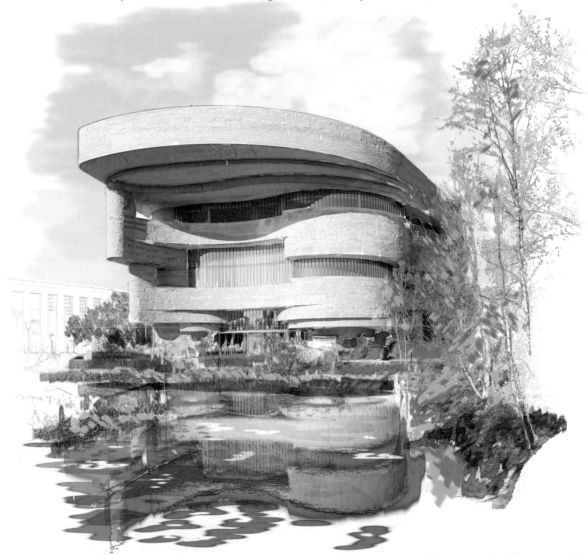

The interior courtyard of the Hirshhorn Museum of Modern Art. The museum was founded on the endowment of industrialist Joseph H. Hirshhorn's 6,000 pieces of contemporary painting, sculpture and photography. The collection has since been greatly expanded by the Smithsonian Institution.

The classical grace and beauty of the memorial to President Lincoln is
very nearly upstaged by what lies within – the giant statue of a seated
Lincoln, flanked by carved inscriptions of the Gettysburg Address of 1863
and Lincoln's Second Inaugural Address (1865). The statue is shown here
at a special moment: the first rays of dawn on midsummer's day.

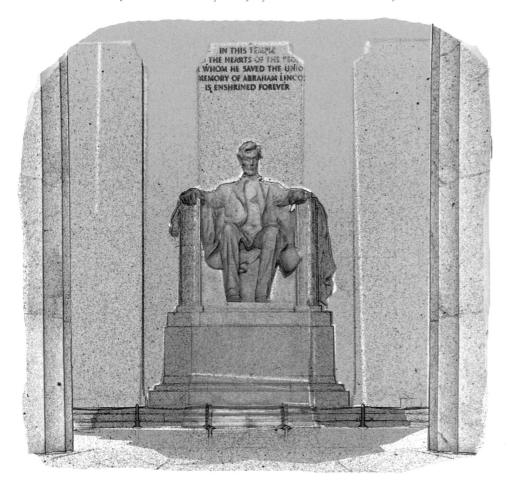

IN THIS TEMPLE
AS IN THE HEARTS OF THE PEOPLE
FOR WHOM HE SAVED THE UNION
THE MEMORY OF ABRAHAM LINCOLN
IS ENSHRINED FOREVER

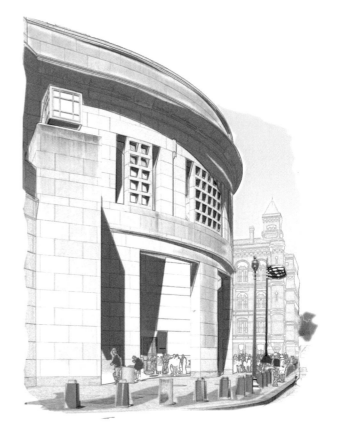

The United States Holocaust Memorial Museum tells the
story of the millions murdered by the Nazis from 1933 to
1945. Its design was intentionally brutal, reflecting the
history within. This is the entrance on 14th Street, SW.

Calder's huge steel-and-aluminum mobile dominates the atrium of the East Building.

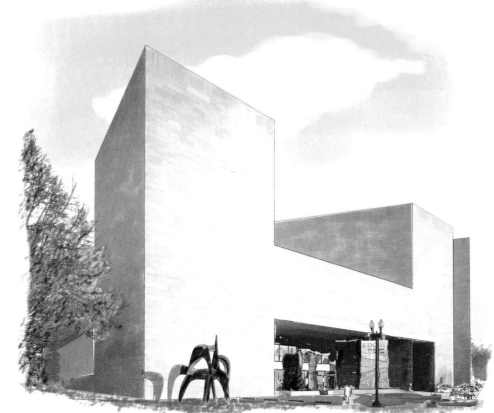

The East Building of the National Gallery of Art, designed by I. M. Pei, is itself a work of modern art. The main entrance displays Henry Moore's bronze representation of male and female forms, "Knife Edge Mirror Two Piece." The sculpture on the left of the sketch is Alexander Calder's "Tom's" (1974).

The National Gallery of Art owes its existence to Andrew Mellon, banker, Treasury Secretary and Ambassador to Britain, who, in 1937, gave his collection of Western art and a large endowment to found it. Other wealthy Americans followed suit and today the gallery houses a world-renowned collection of Western paintings and sculpture from the Renaissance to the present. The original gallery, above, now known as the West Building, opened in 1941.

Interior of the East Building of the National Gallery of Art.

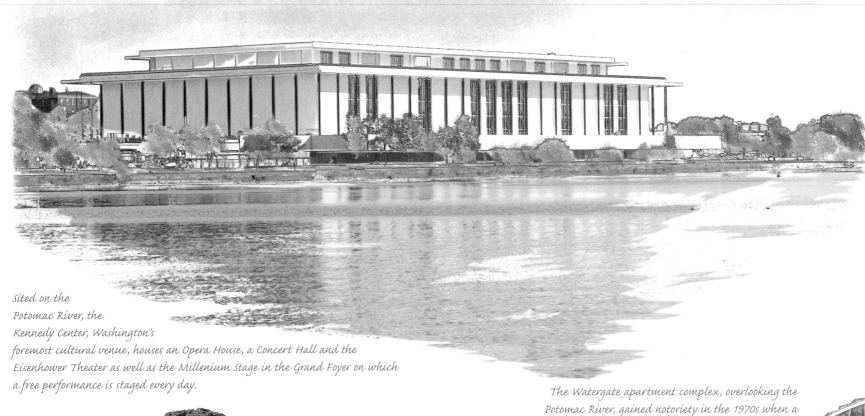

Sited on the
Potomac River, the
Kennedy Center, Washington's
foremost cultural venue, houses an Opera House, a Concert Hall and the
Eisenhower Theater as well as the Millenium Stage in the Grand Foyer on which
a free performance is staged every day.

The Watergate apartment complex, overlooking the
Potomac River, gained notoriety in the 1970s when a
group of political operatives burgled offices of the
Democratic Party. Their arrests eventually led to the
resignation of President Richard Nixon.

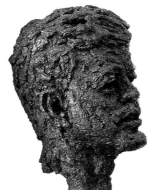

The seven-foot-high
bronze bust of JFK by
sculptor Robert Berks
marks the Center's
Grand Foyer.

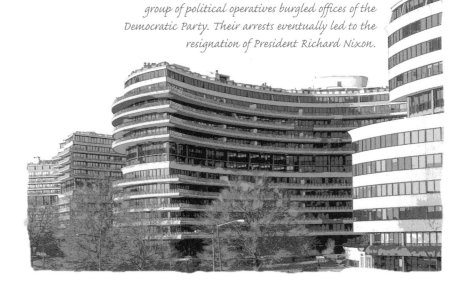

Constitution Hall was opened in 1929 and for many years its 3,700-seat auditorium, still the largest in the city, was Washington's principal concert hall.

The Corcoran Gallery of Art.

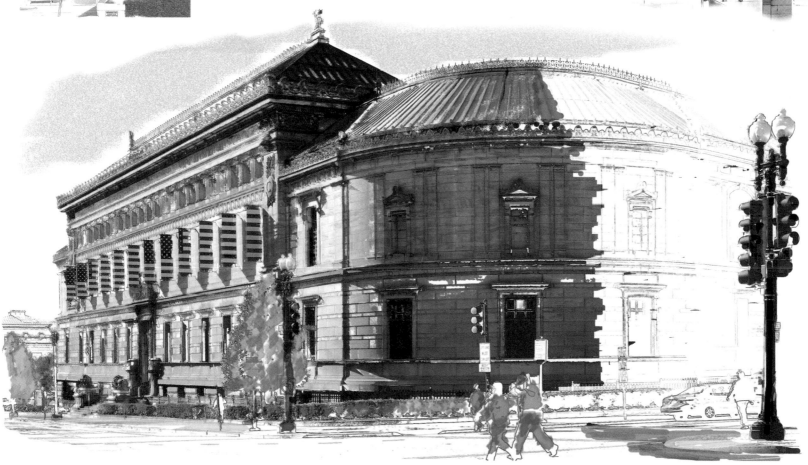

The Corcoran Gallery of Art, Washington's largest museum outside of the Smithsonian complex, houses important collections of American and European art and has an accredited College of Art.

The National World War II Memorial, which embraces a restoration of the Rainbow Pool between the Lincoln Memorial and the Washington Monument, was opened in May 2004. Fifty-six pillars representing the US States and Territories at the time of the war form the outer boundaries of the memorial's plaza. The District of Columbia pillar is on the right of this view.

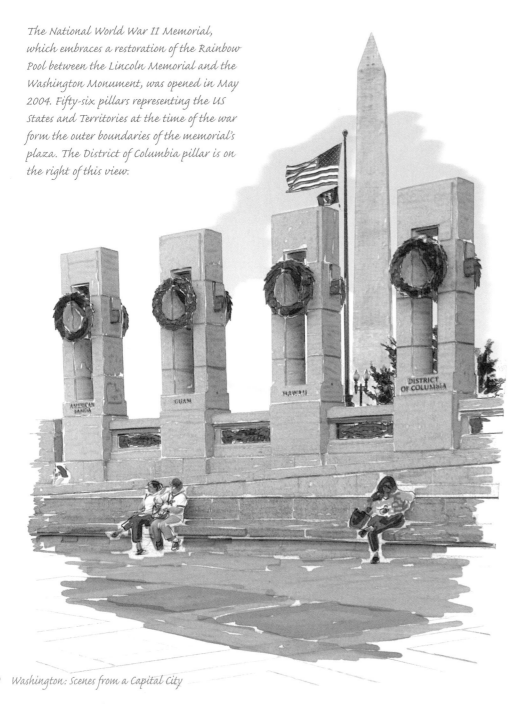

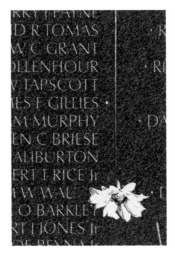

The Vietnam Veterans Memorial has to be one of the most moving monuments in Washington. Its wall of polished black slabs, cut into the earth and bearing only the names of over 58,000 Americans who died in the conflict, is a place of quiet reflection.

The District of Columbia World War I Memorial honors the men and women of the District who served in WWI. At its dedication by President Herbert Hoover at 11 a.m. on Armistice Day, 1931, John Philip Souza led the US marine band.

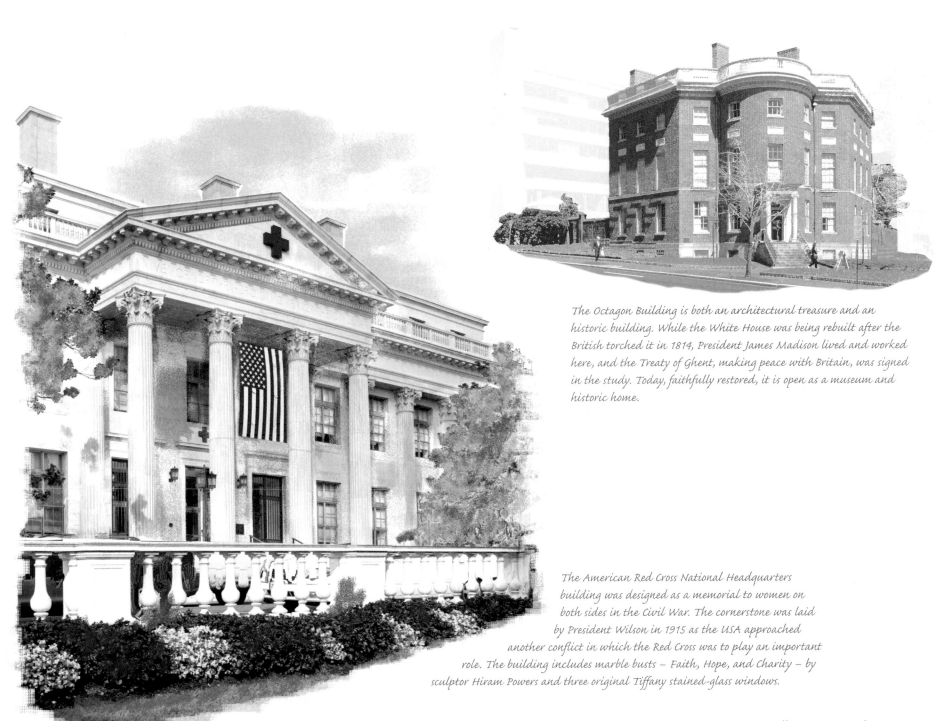

The Octagon Building is both an architectural treasure and an historic building. While the White House was being rebuilt after the British torched it in 1814, President James Madison lived and worked here, and the Treaty of Ghent, making peace with Britain, was signed in the study. Today, faithfully restored, it is open as a museum and historic home.

The American Red Cross National Headquarters building was designed as a memorial to women on both sides in the Civil War. The cornerstone was laid by President Wilson in 1915 as the USA approached another conflict in which the Red Cross was to play an important role. The building includes marble busts – Faith, Hope, and Charity – by sculptor Hiram Powers and three original Tiffany stained-glass windows.

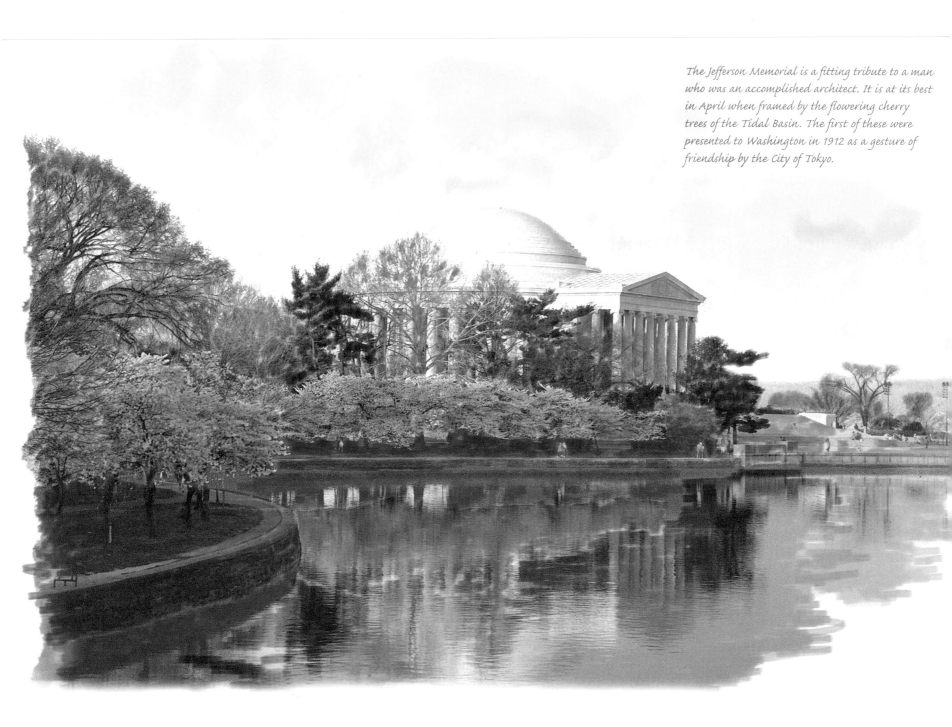

The Jefferson Memorial is a fitting tribute to a man who was an accomplished architect. It is at its best in April when framed by the flowering cherry trees of the Tidal Basin. The first of these were presented to Washington in 1912 as a gesture of friendship by the City of Tokyo.

The Franklin D. Roosevelt Memorial is not only to the man but also to the era he represents. Located between the cherry-tree walk beside the Tidal Basin and the Potomac River, the monument traces 12 years of American history through a sequence of outdoor rooms – each one devoted to one of FDR's four terms in office.

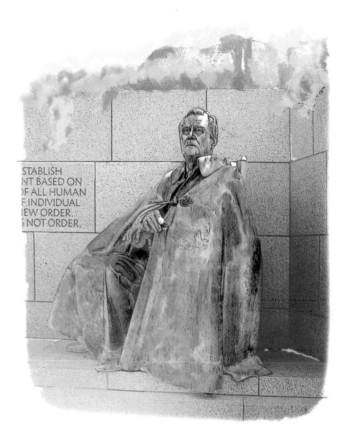

The entrance to the Memorial. Lawrence Halprin's design is the most expansive of the national memorials in Washington.

A bas-relief by Robert Graham in the second room depicts social programs of the New Deal.

Waterfalls and shady alcoves create the feeling of a secluded garden.

Neil Estern's statue of Roosevelt as a seated figure is in the third room. His beloved dog, Fala, sits nearby.

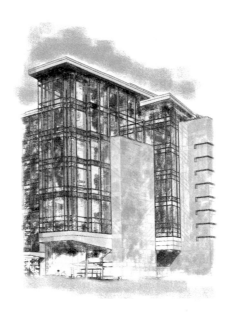

Downtown and Georgetown

Washington's downtown reinvented itself in the last two decades of the twentieth century. First came the vast public–private effort to rebuild the northern edge of Pennsylvania Avenue, which is the downtown's southern border. Then followed the construction cranes of private capital, building on every possible vacant lot—and some not vacant, as remnants of the nineteenth-century city bit the dust to make way for new, taller office buildings and, here and there, new hotels and condominiums or rental apartment houses.

The net result is a compact, vital employment center and entertainment district that, fortunately, preserves enough of its old self to tell important bits and pieces of the city's history. A notable turning point came in 1997 when the opening of the new MCI Center (now the Verizon Center),

home to the city's professional basketball and hockey teams, helped to spur the comeback of restaurants, stores, night clubs and theaters. Within a couple of blocks, the Bard (at the Shakespeare Theatre on Seventh Street) and the Washington Wizards now vie for a customer's attention.

Georgetown had its down years, too, but it never suffered the pain of wholesale redevelopment. True, there's not much on its Potomac waterfront to remind you of its days as a port and industrial outpost—and thankfully so, for messy (and smelly) plants have been replaced with offices, residences, restaurants and cinemas. Busy M Street is a dividing line—to its north, away from the river, Georgetown remains a fascinating architectural potpourri of the elegant and the ordinary sharing space on shady residential streets.

Extensive high-tech glass cladding in the new Convention Center (opposite) allows sunlight to stream in whilst filtering heat out.

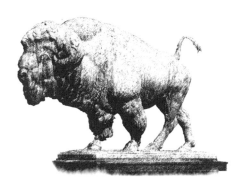

Sculptor Phimister Proctor's bison have guarded the entrance to Georgetown on Q Street, NW, since 1914.

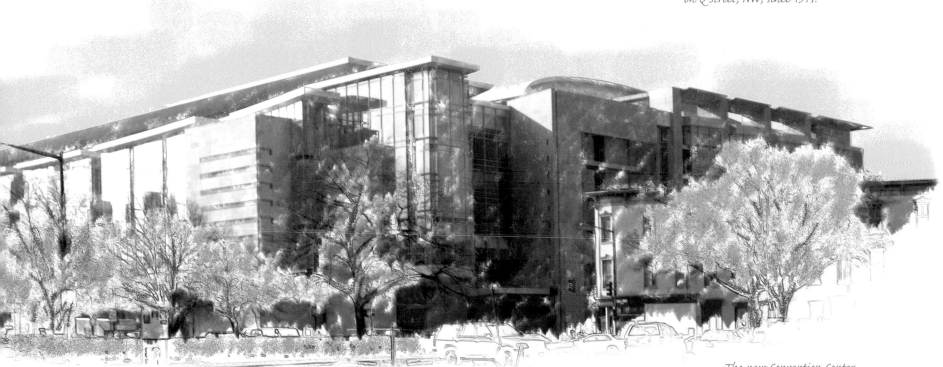

The new Convention Center, covering six city blocks, is the largest structure in the city. It offers more than 700,000 square feet of exhibit space and 125,000 square feet of meeting areas.

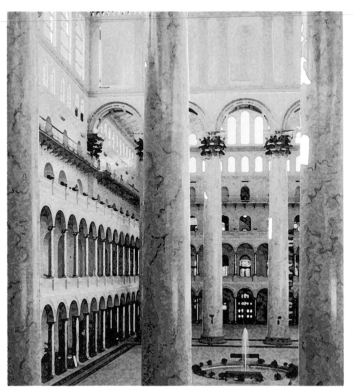

The National Building Museum was opened in 1985, dedicated to American achievements in architecture, urban planning, construction, and design. Corinthian columns, brick-built but painted to resemble Siena marble, dominate the Great Hall which is 316 feet long and 159 feet high.

A three-foot-tall, 1,200-foot-long terracotta frieze, depicting life in the Union forces during the Civil War, encircles the museum building.

Known for years as the "Old Pension Building," the magnificent museum building originally housed the staff administering pensions for Civil War veterans. It was designed by General Montgomery C. Meigs in the style of an Italian palazzo.
The Law Enforcement Officers Memorial is in the foreground.

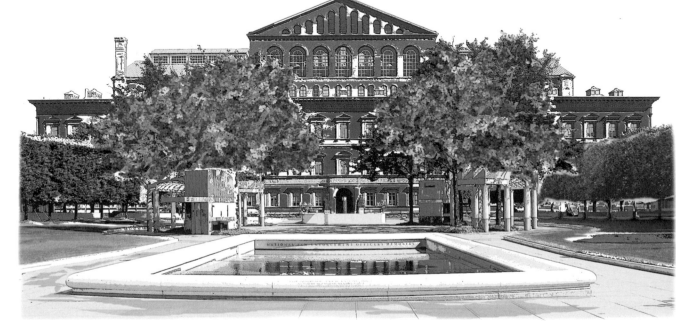

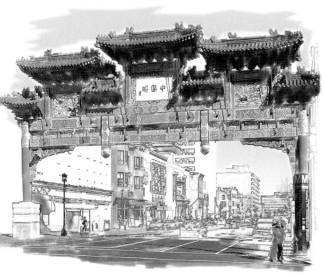

The brightly painted "Friendship Archway," given in 1986 as a gesture of friendship in a Beijing–Washington exchange, is the center of the city's small Chinatown area. It is the world's largest single-span Chinese archway.

Street lights in Chinatown have a unique style.

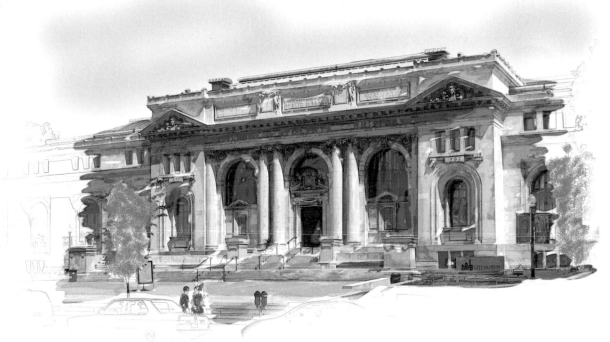

The City Museum opened in May 2003 in the glistening century-old former Carnegie Library building. The museum provides an overview of the city of Washington – the vision that created it, the influences that shaped it, and the people who call the nation's capital their home.

Washington's modern Metro system has five lines linking the center with the suburbs.

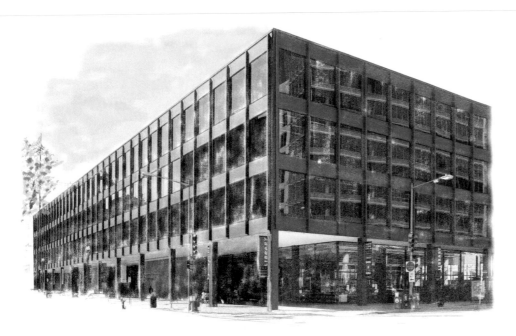

With the construction, in 2002, of the new headquarters of the Potomac Edison Power Co. (PEPCO) – directly across Ninth Street from Ludwig Mies van der Rohe's Martin Luther King Jr. Library – the intersection of Ninth and G has become one of the more architecturally compelling corners in the whole of downtown.

The Martin Luther King Jr. Memorial Library is the headquarters of DC's public library system. Opened in 1972 it houses a major collection of sources on, and photographs of, Washington history. A striking mural by Don Miller, illustrating the life and times of Martin Luther King Jr. and the history of the civil rights movement, covers a full wall of the lobby.

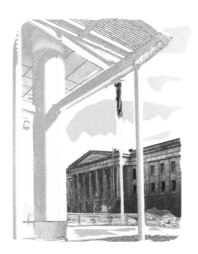

The National Patent Office, described by Walt Whitman as "the noblest of Washington buildings," was used as a hospital during the Civil War. It now houses the Museum of American Art (seen through the portico of the PEPCO building) and the National Portrait Gallery.

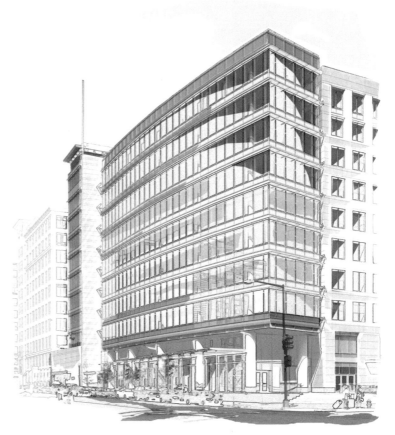

No single event contributed more to the revitalization of Washington's downtown than the opening of the MCI Center (renamed in 2006, Verizon having taken over MCI), a stadium which itself houses shops and restaurants and has spawned the opening of a plethora of new facilities, offices and residences.

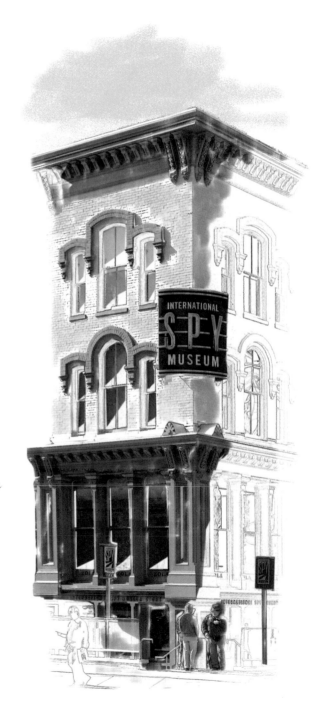

Devoted to the clandestine world of intelligence gathering, the privately owned International Spy Museum was opened in 2002. This part of the museum, the gracious LeDroit Building, is one of the oldest remaining office buildings in the city.

The modern 20,000-seat Verizon arena fits surprisingly harmoniously into its historic neighborhood partly by the use of varied materials and glass.

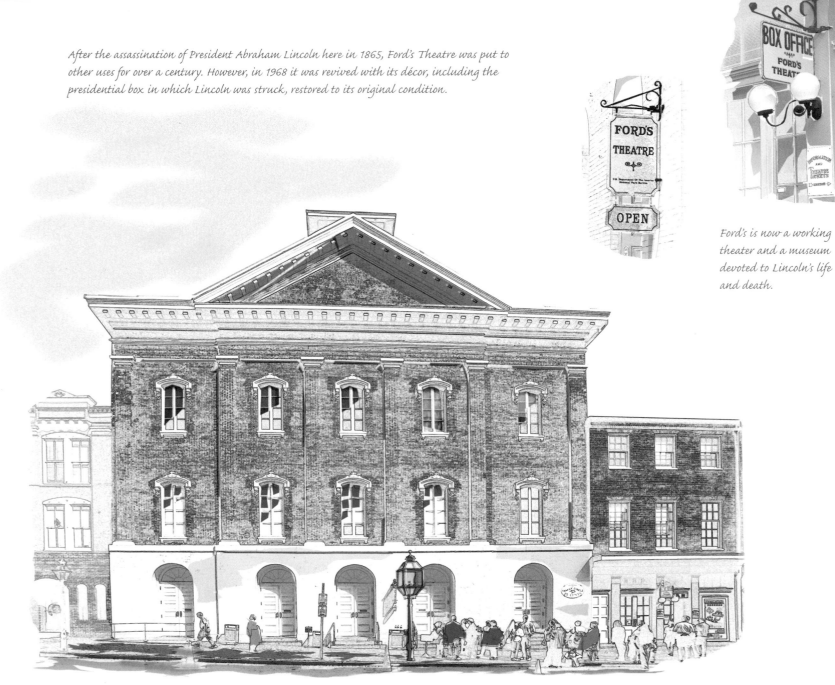

After the assassination of President Abraham Lincoln here in 1865, Ford's Theatre was put to other uses for over a century. However, in 1968 it was revived with its décor, including the presidential box in which Lincoln was struck, restored to its original condition.

Ford's is now a working theater and a museum devoted to Lincoln's life and death.

Union Station, Washington's main-line railway station, was opened in 1907. It replaced two earlier terminals, one of which – the Baltimore and Potomac Railroad Depôt – was located on the Mall where the National Gallery of Art now stands. During and after WWII it suffered from under-funding and neglect but, following a major public-private restoration, was reopened in 1988 as a rail, shopping and entertainment center. The view shows part of the 760-foot long Grand Concourse, one of the largest public spaces in the United States.

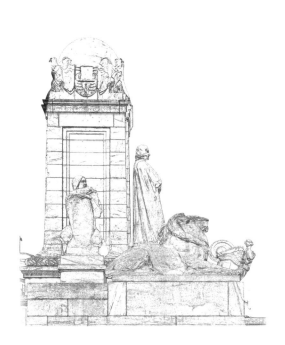

In sculptor Lorado Taft's Columbus Memorial Fountain, erected on Union Station Plaza in 1912, the explorer stands at the prow of his ship flanked by crouching male and female figures representing the Old World and the New.

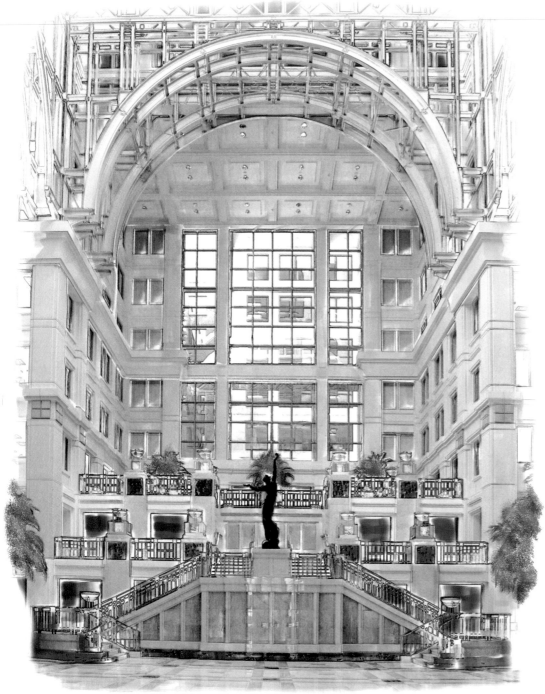

The Homer Building, an historic landmark, was restored and expanded in 1990 by Akridge, raising the building to 12 stories, centered on a full-height atrium. The sculpture in front of the grand staircase is "Spirit of American Youth" by Donald Harcourt DeLue. It is one of a series of 12 works commemorating the D-Day landing at Omaha Beach in 1944.

A working Greyhound Bus Station until the 1980s, and one of the city's more important Art-Deco monuments, this sleek downtown terminal has been preserved and incorporated into the modern office which frames it.

The crest of the Woodward and Lothrop department store, a downtown institution from 1902 to 1995, embellishes the splendid beaux-arts building, now restored for retail and office use.

Cast-iron Fire & Police call boxes were in use in the city from the 1860s until the 1970s. The DC Heritage Tourism Coalition is coordinating a restoration program.

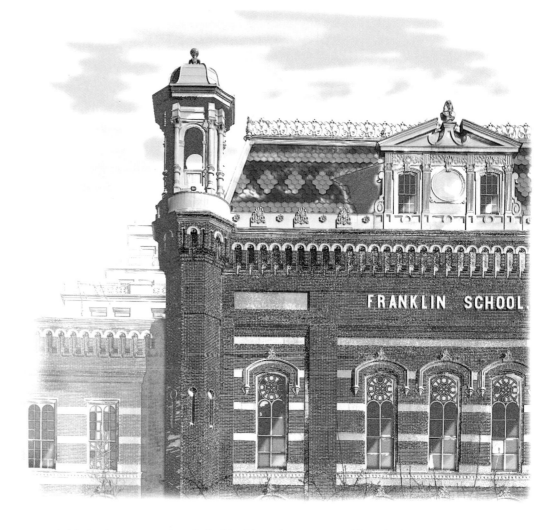

Regarded in its day an exemplar of school building, the ornate Franklin School dominates Franklin Square, both named for founding father, philosopher and inventor, Benjamin Franklin. It was from here that Alexander Graham Bell sent the first wireless message.

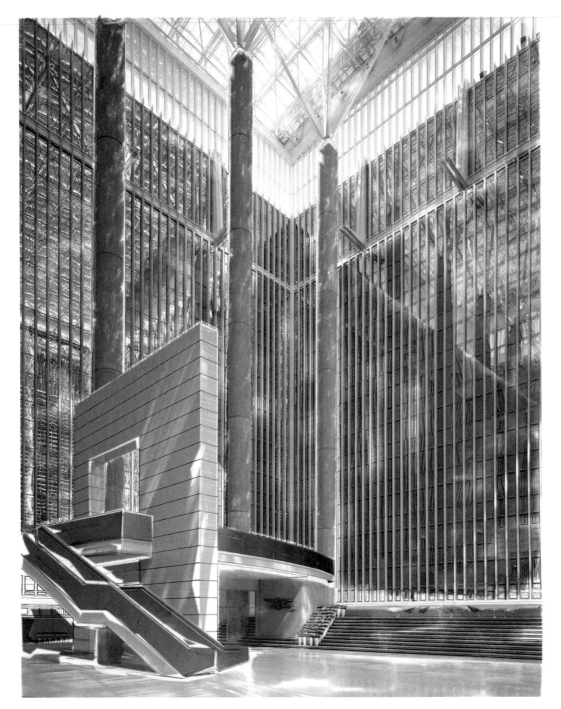

The World Bank is the largest multi-national organization in Washington. It is owned by more than 180 countries, of which the US is the largest shareholder, and lends some $25 billion a year for social, infrastructure, and poverty alleviation programs to its developing country members. Its modern new headquarters is built around a light-filled central atrium.

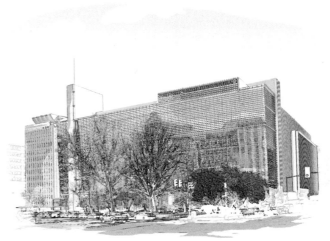

Seen from across Pennsylvania Avenue, the Bank's main complex occupies a whole city block.

Turning Corners.
A challenge for architects is to provide interest at the corners
of their buildings. Downtown Washington provides a host of
examples where the corner becomes the key feature of the design.

1225 Eye Street, NW. The saw-tooth corner increases corner office space looking out to Franklin Square.

2401 Pennsylvania Avenue, NW. The façade of this mixed-use building is decorated with political imagery and the corner incorporates stone flag masts with the DC flag and the Stars and Stripes.

Presidential Plaza at 900 19th Street, NW. A clock tower is used to anchor the corner of this Art-Deco-style building.

Georgetown was founded in 1751 when the settlers at the head of navigation on the Potomac were granted a town charter and named their flourishing port after King George II. By 1791, when it was included within the new federal district, it was America's largest tobacco port.

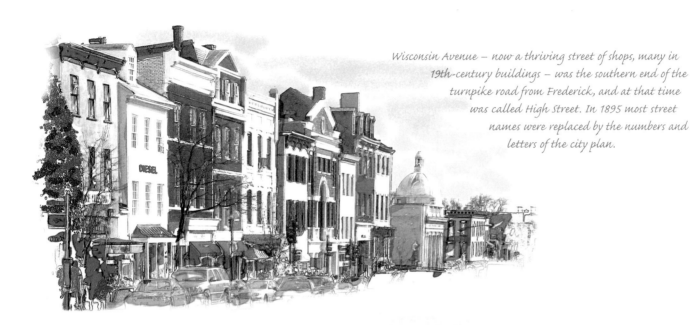

Wisconsin Avenue – now a thriving street of shops, many in 19th-century buildings – was the southern end of the turnpike road from Frederick, and at that time was called High Street. In 1895 most street names were replaced by the numbers and letters of the city plan.

The Vigilant Fire House in Georgetown is the oldest in Washington.

The Old Stone House at 3051 M Street, NW, was built in 1765 by Christopher Layman, a cabinetmaker, as his home and workshop. It is the oldest surviving structure built in Washington. Restored by the National Park Service to its pre-Revolutionary appearance, it is now open to the public.

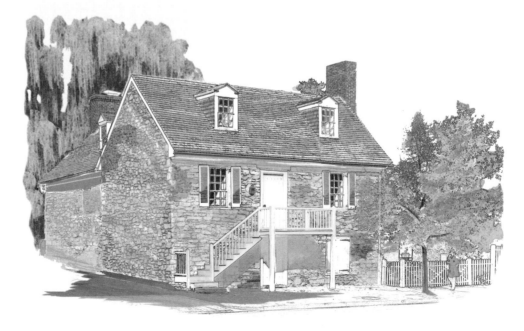

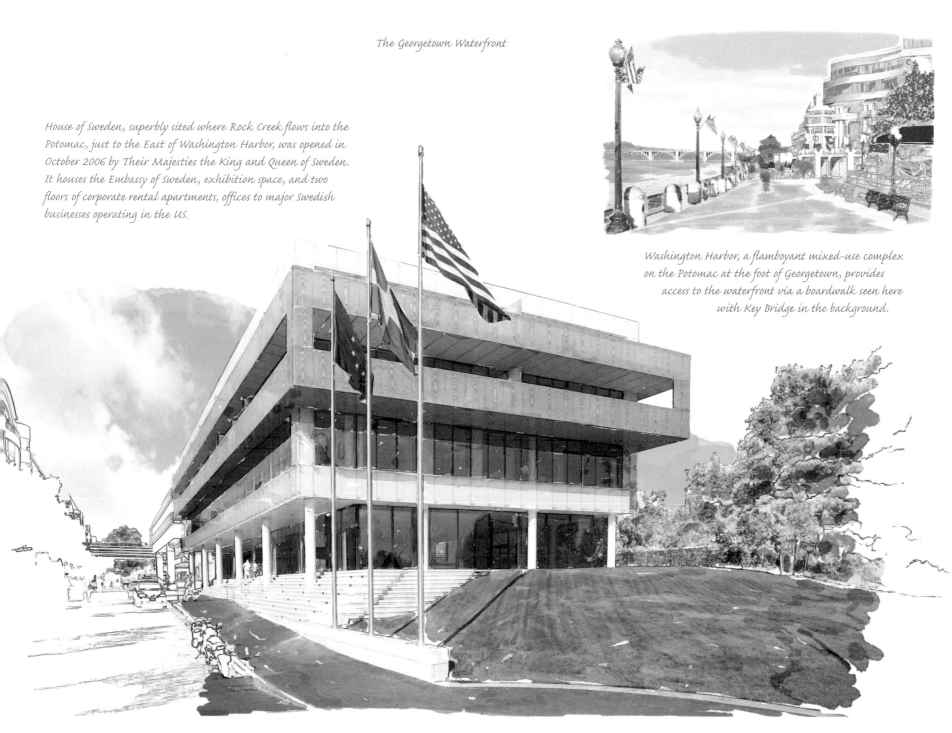

The Georgetown Waterfront

House of Sweden, superbly sited where Rock Creek flows into the Potomac, just to the East of Washington Harbor, was opened in October 2006 by Their Majesties the King and Queen of Sweden. It houses the Embassy of Sweden, exhibition space, and two floors of corporate rental apartments, offices to major Swedish businesses operating in the US.

Washington Harbor, a flamboyant mixed-use complex on the Potomac at the foot of Georgetown, provides access to the waterfront via a boardwalk seen here with Key Bridge in the background.

A hat shop on Wisconsin Avenue in Georgetown.

Antique shops in converted period houses are typical of upper Wisconsin Avenue.

These colorful row houses on Q Street, NW, are part of the later 19th-century expansion of Georgetown.

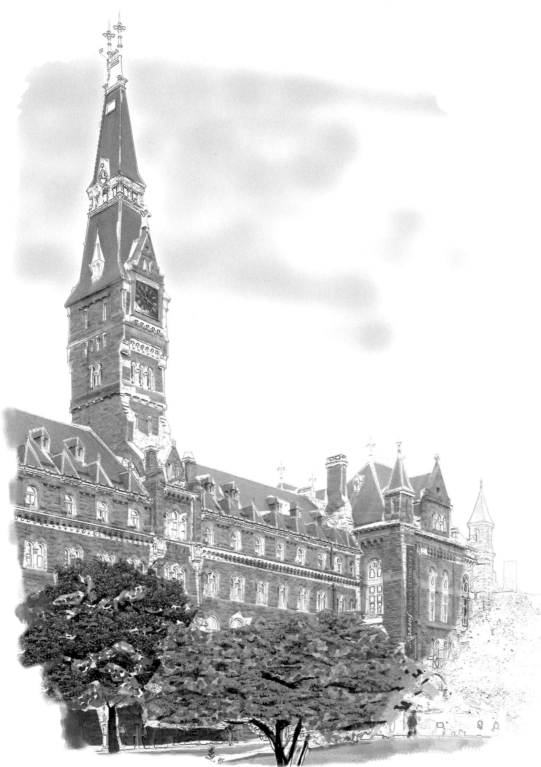

The Chesapeake & Ohio (C&O) canal, opened in 1824, was built to carry products of the American West – lumber, coal, whiskey and grain – from Cumberland, Maryland, 184 miles to the port of Georgetown on the Potomac River. Made obsolete by the arrival of the railway, the canal was declared a National Park in 1971.

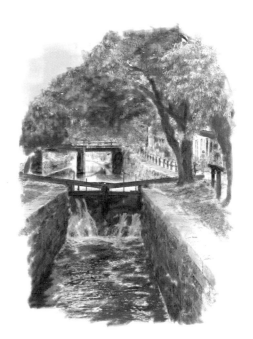

Healy Hall is the dominant building of the campus of Georgetown University, the country's first Roman Catholic university, founded in 1789. The Hall is named for Patrick Healy, SJ, President of Georgetown from 1873 to 1882. Healy, the son of a slave and a plantation owner, was the first African American to become president of a university in the United States.

Tudor Place, a truly wonderful neoclassical house, is set in five-and-a-half acres of gardens in the heart of Georgetown. It was built for Thomas Peter and his wife Martha, the granddaughter of Martha Washington, and was lived in by six generations of the family. It is now open to the public as a historic house with furnishings from its 180-year occupancy.

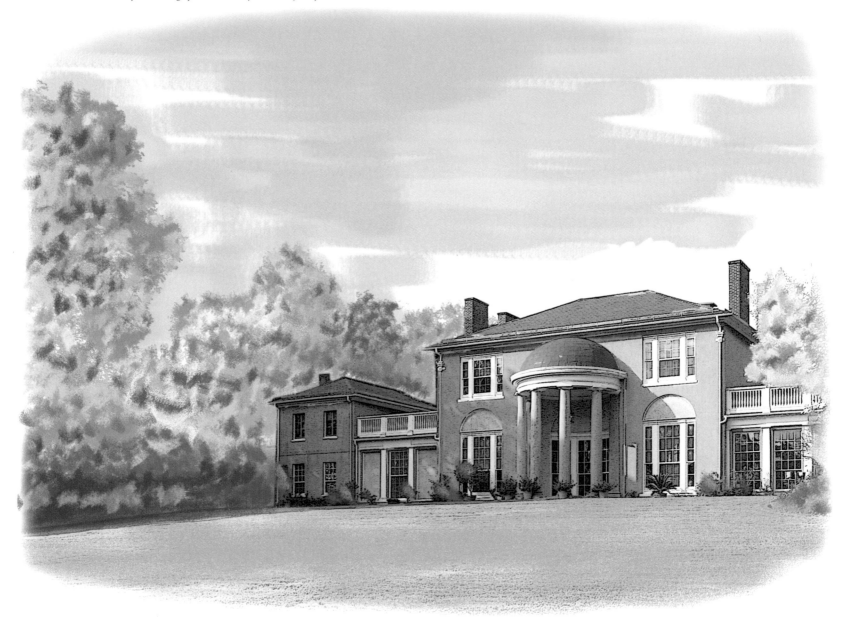

In 1944 two international conferences held at Dumbarton Oaks
determined the principles incorporated into the charter of the
United Nations that was established the following year.

The original Dumbarton Oaks, a
red-brick Federal-style mansion,
was built on a 53-acre site above
Georgetown in 1801. Over the years
many changes were made to the
house and to the gardens that are,
today, a masterpiece of terraced
landscaping.

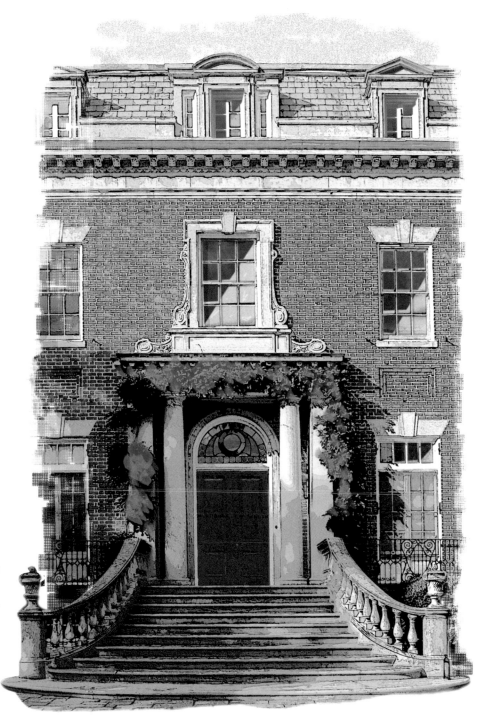

Uptown

The word "uptown" is often just a figure of speech used to describe terrain that is outside of, but not necessarily higher than, "down" town. But Washington's uptown is literally up, built on and beyond the hills around the riverside basin where L'Enfant laid out much of his city. It is "up," too, in social status—as the city grew, many of the tree-shrouded heights were occupied by wealthy families as cooling retreats from the summertime heat of the basin.

Eventually, these early estates were subdivided into plots for rather grand single-family homes. The avenues linking these new neighborhoods to downtown—either extensions of L'Enfant's diagonals, such as Connecticut and Massachusetts Avenues, or refinements of old roads, such as Rockville Pike, today's Wisconsin Avenue—became, in themselves, worthy addresses.

Massachusetts Avenue northwest of Dupont Circle, for instance, became today's elegant Embassy Row. To anyone interested in modern architecture, it is rewarding to see that in the second half of the twentieth century architects were able to add choice contemporary notes to this fine chorus of the traditional, as the embassies of Brazil, Finland and Italy notably attest.

Washington's heights also attracted foresightful institutions—Georgetown, Howard and Catholic Universities all settled on hills with commanding views of the capital. The Washington National Cathedral is in a class by itself—a huge Gothic building constructed stone block by stone block (with just a minimal amount of reinforced steel) entirely in the twentieth century. When seen from the Virginia side of the Potomac, its towers share the symbolic skyline with the Capitol and Washington Monument.

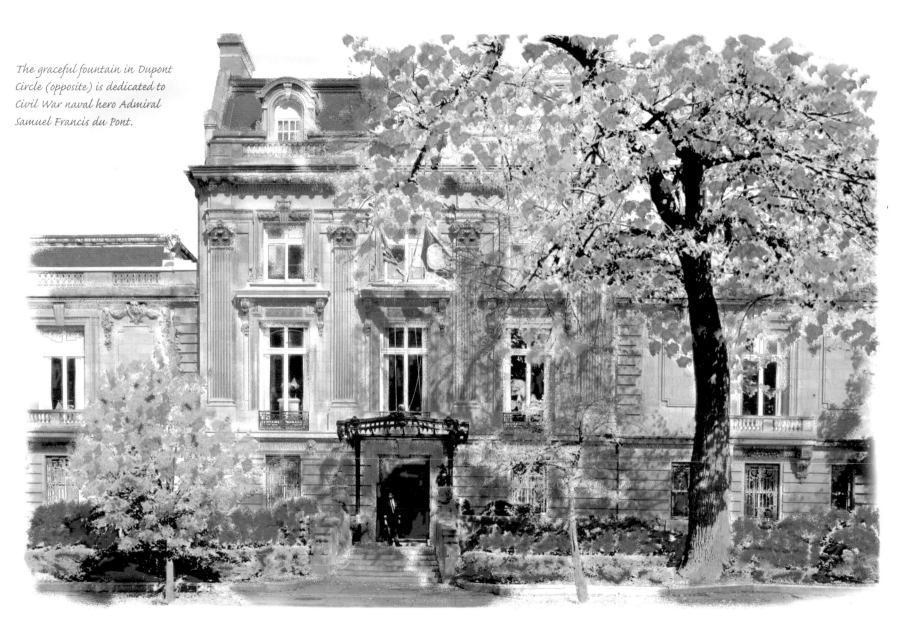

The graceful fountain in Dupont
Circle (opposite) is dedicated to
Civil War naval hero Admiral
Samuel Francis du Pont.

The premises of the prestigious Cosmos Club for Washington's achievers in diverse fields is a glorious mansion originally built for
railway baron Richard Townsend. Because of a fortune-teller's warning that Mrs. Townsend would die under a new roof, the
chateau was built around another already on the site.

Patterson House now houses the Washington Club. It was in this gleaming white, highly ornate building, which recalls 16th-century Italian palazzos, that President and Mrs. Coolidge entertained Charles Lindbergh after his solo transatlantic flight in 1927.

Anderson House is now the home of the Society of Cincinnati, a benevolent organization established by George Washington for his officers and their direct male descendants.

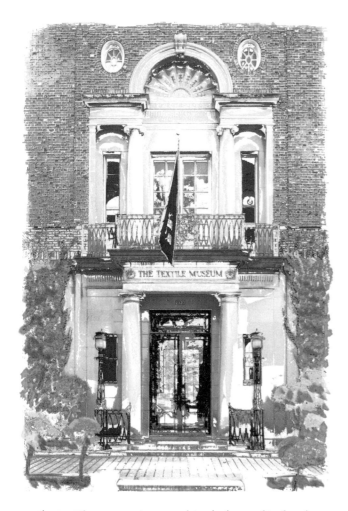

The Textile Museum is centered in the house of its founder, George Myers, and his original collection of some 300 oriental rugs and textiles. The museum's holding has now expanded to over 15,000 items.

Built in 1915 for Edward Everett, who owed much of his fortune to his invention of the fluted bottle cap, this is the most picturesque of the mansions on Sheridan Circle, one of the city's finest residential neighborhoods. It was the Embassy of the Republic of Turkey from 1932 until 1989 when it became the Ambassador's residence.

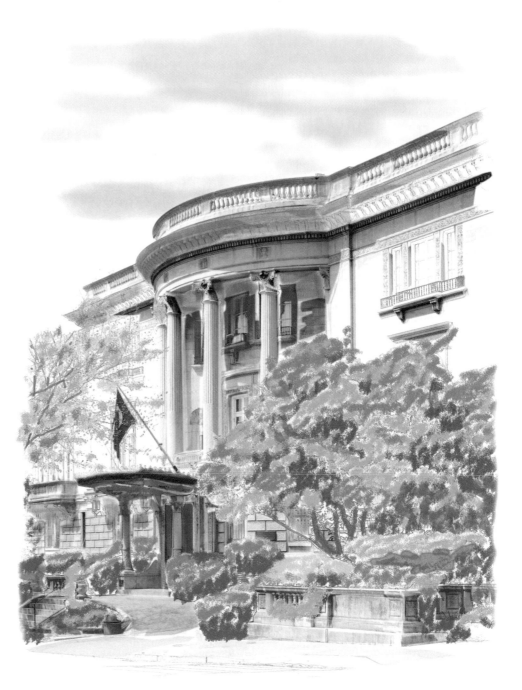

A heraldic lion sits atop the wall surrounding Sir Edward Lutyens' British Embassy building.

The graceful proportions of the British Embassy make it one of the distinctive buildings of Massachusetts Avenue. The renowned embassy gardens were begun in 1930 by the American-born wife of the first ambassador to live here, Sir Ronald Lindsey.

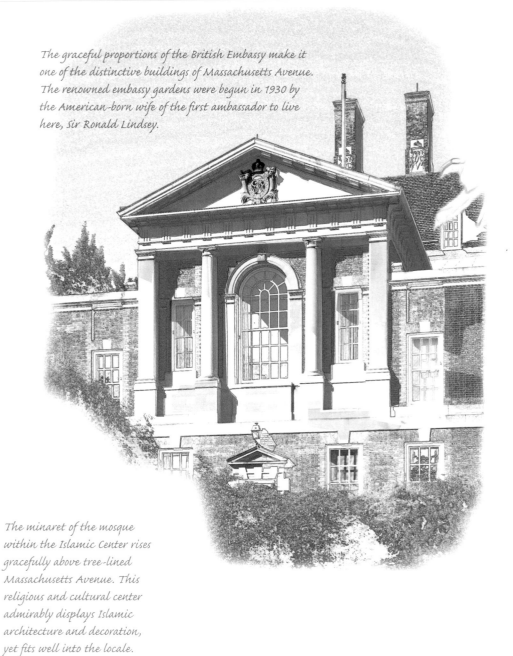

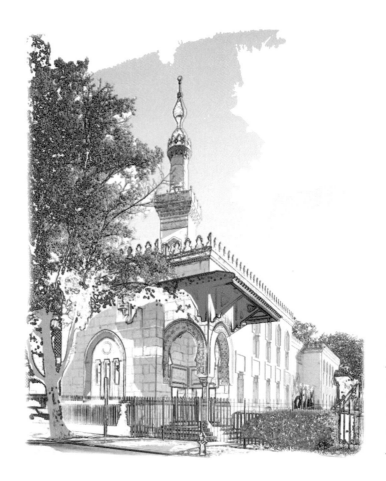

The minaret of the mosque within the Islamic Center rises gracefully above tree-lined Massachusetts Avenue. This religious and cultural center admirably displays Islamic architecture and decoration, yet fits well into the locale.

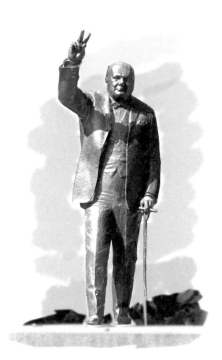

Sir Winston Churchill stands with
one foot on United States soil and the
other within the grounds of the
British Embassy, symbolizing his
Anglo-American descent.

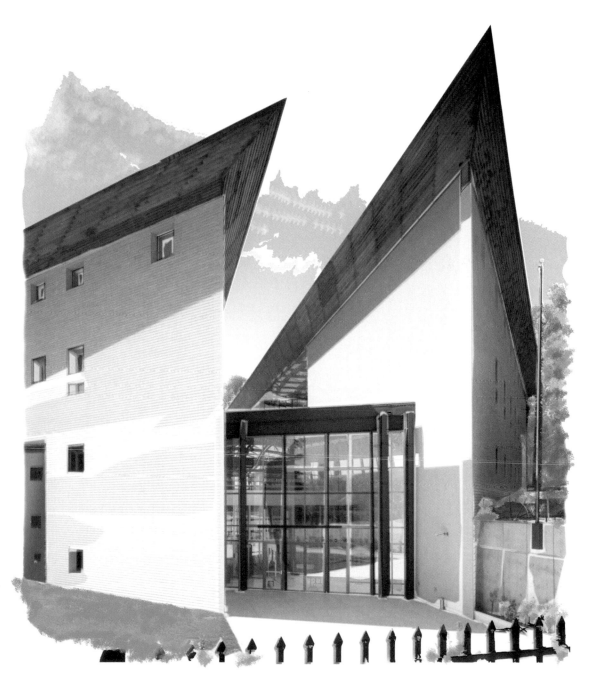

The dramatic new Italian Embassy, just off
Massachusetts Avenue, is a square building divided
by a diagonal cut through close to the center – to
reflect the original shape of the District of Columbia
bisected by the Potomac River.

The beautiful Cathedral Church of St. Peter and St. Paul
is more familiarly known as the Washington National
Cathedral. The west façade with its two 235-foot towers
faces Wisconsin Avenue.

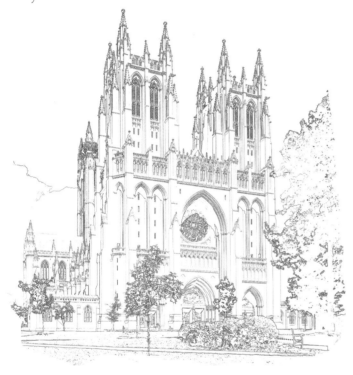

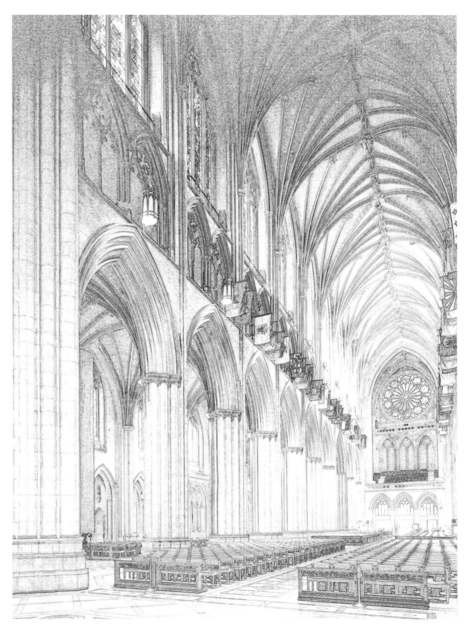

The cornerstone of the Cathedral was laid by
President Theodore Roosevelt in 1907 and the
building essentially completed in 1990. The
fine west rose window by Rowan LeCompte
illuminates the soaring nave.

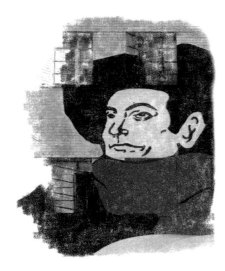

Adams-Morgan: a mural brightens the front of one of the many restaurants in this vibrant and ethnically diverse neighborhood.

Four concrete lions guarding the ends of the Taft bridge are from originals by Roland Hinton Perry.

Named for the 27th president, the Taft Bridge carries Connecticut Avenue across the Rock Creek gorge. When built it was the largest reinforced concrete bridge in the world.

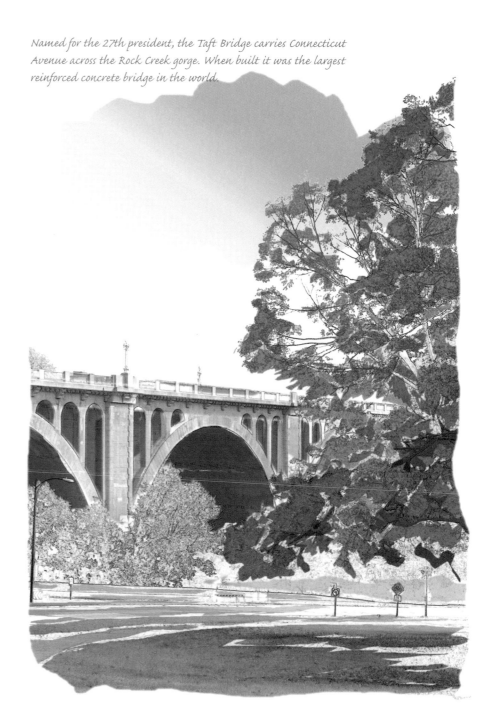

The classic Broadmoor apartment block sits on a five-acre site surrounded by landscaped lawns. Among many famous residents, then Representative and Mrs. Richard Nixon lived here in 1947.

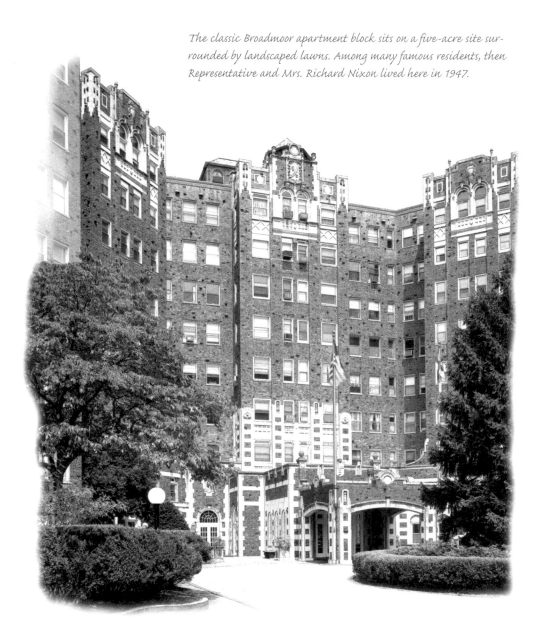

Many of the decorative elements are heraldic, such as the one over this front doorway.

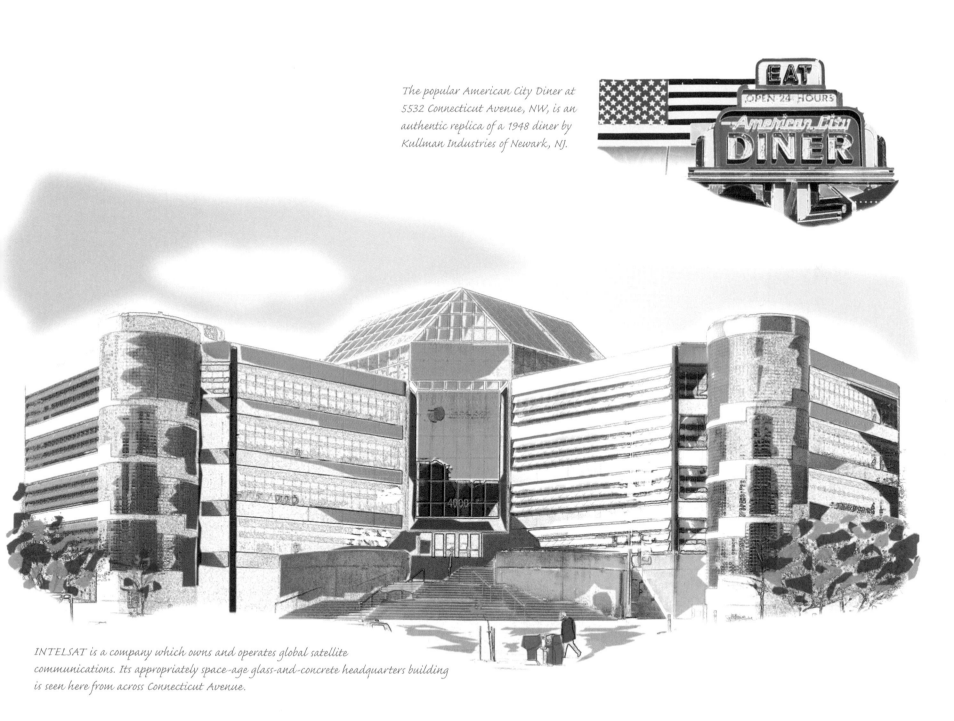

The popular American City Diner at 5532 Connecticut Avenue, NW, is an authentic replica of a 1948 diner by Kullman Industries of Newark, NJ.

INTELSAT is a company which owns and operates global satellite communications. Its appropriately space-age glass-and-concrete headquarters building is seen here from across Connecticut Avenue.

Friendships Heights is a major shopping center on Wisconsin Avenue at the boundary of the District of Columbia and Maryland.

A pair of markers sporting the seal of the District of Columbia were placed near the boundary between DC and Maryland in 1932 by a local garden club.

Growth was stimulated by the opening of the Metro rail system.

Over 100 other stores line Wisconsin Avenue on either side of the State boundary and major new retail, office and residential developments are under way or planned in both DC and Maryland.

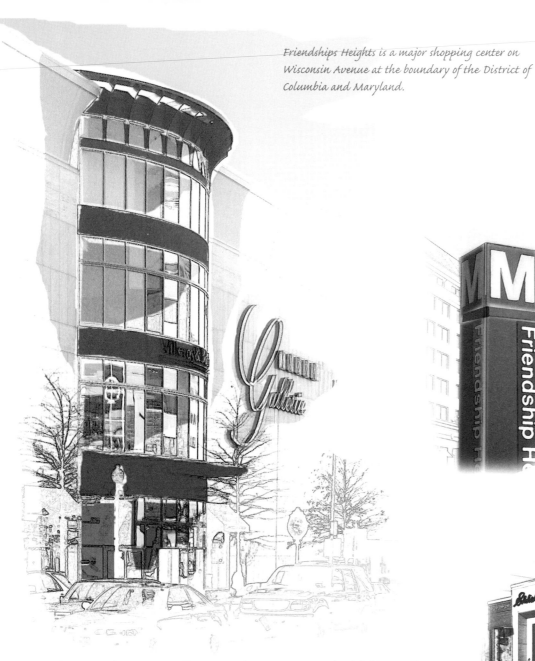

The up-market Mazza Gallerie, opened in 1977 as an enclosed fashion mall, was the original anchor of the center. It has been continually modified to make it more visually accessible, and the red finish in the sketch has now become silver-grey. The mall contains some 50 stores and a multiplex cinema.

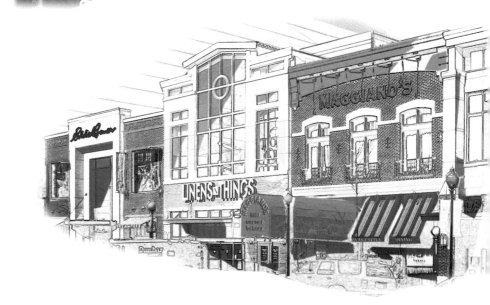

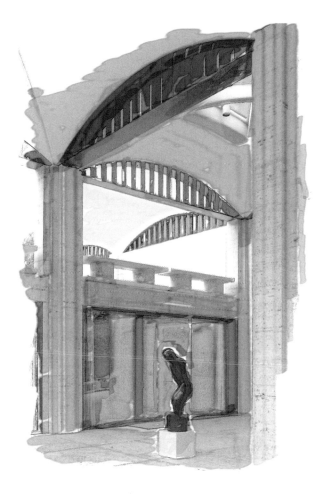

The sculpture gallery of the Kreeger Museum opened in 1994.

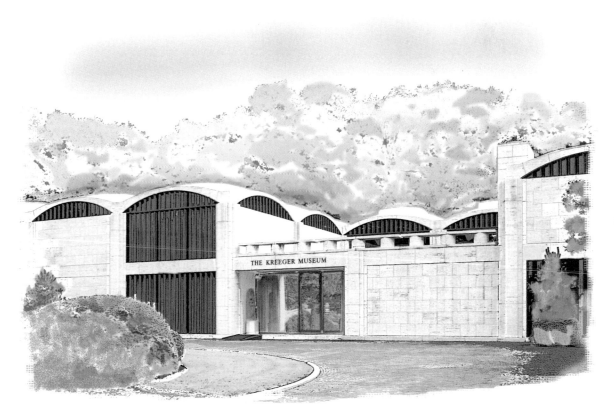

The elegant travertine-clad post-modern Kreeger Museum, set in five-and-a-half acres of woodland was formerly the home of insurance executive, philanthropist and art-lover, David Lloyd Kreeger and his wife, Carmen. It was built to house their outstanding collection of paintings and sculpture.

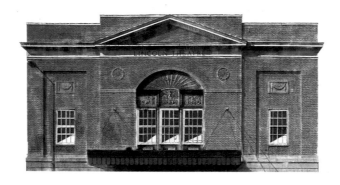

East of Rock Creek

A cliché has it that Rock Creek Park, for all of its glories, cuts a swath through the city that divides rich from poor, white from black—and it's largely true. Areas west of the park do indeed tend to be wealthier and whiter than those to the east. But visitors—and for that matter, residents—who confine their explorations to one side or the other are missing much of the city's history and cultural life.

By staying west of the park one would miss, for instance, the northeast district once known as "little Rome" because of the number of Roman Catholic institutions it was home to. Many, in fact, still exist, including most notably the Catholic University of America and The Shrine of the Immaculate Conception, the polychrome dome of which is one of the city's more notable landmarks. Or, one might miss the extraordinary views of the city from many a hill on the other side of the city's second river, the Anacostia. On one of those hills stands Cedar Hill, home to "the great orator," abolitionist Frederick Douglass. The house is now a national landmark.

But more than anything else one would miss the many manifestations, both past and present, of African American culture. U Street, for example. During nearly eight decades of racial segregation a stretch of this street, extending west from Seventh Street nearly to 18th Street, became a vibrant strip of theaters and jazz clubs that hosted, and nurtured, some of America's greatest talents in music and the performing arts—including, of course, native son Edward Kennedy ("Duke") Ellington.

Ironically, the street went into decline as integration lured many African American professionals to the suburbs. Riots following the assassination of Martin Luther King Jr. in 1968 definitively ended its run as the "black Broadway." But U Street re-emerged in the 1990s as a favored destination for the young and the hip. These days, it is hard to get a weekend table at its many multi-ethnic restaurants, bars and music spots.

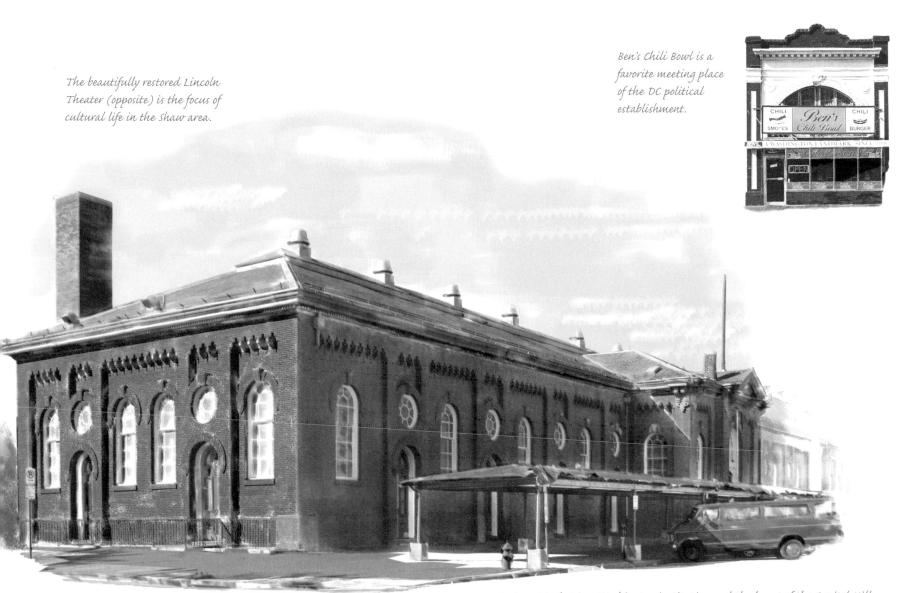

The beautifully restored Lincoln Theater (opposite) is the focus of cultural life in the Shaw area.

Ben's Chili Bowl is a favorite meeting place of the DC political establishment.

CHILI SMOKES

Ben's Chili Bowl

CHILI BURGER

A WASHINGTON LANDMARK SINCE

OPEN

Eastern Market is a Washington institution and the heart of the Capitol Hill community. A source for fresh-from-the-farm vegetables, fruits, meat, eggs, bread, and fish, it is the last of several markets which provided fresh produce for Washingtonians in the 19th century. Its interior is to be completely restored after being badly damaged by fire on 30 April, 2007.

Founders Library dominates the campus of Howard University, which was established in 1867. The library clock tower has become an icon of Howard.

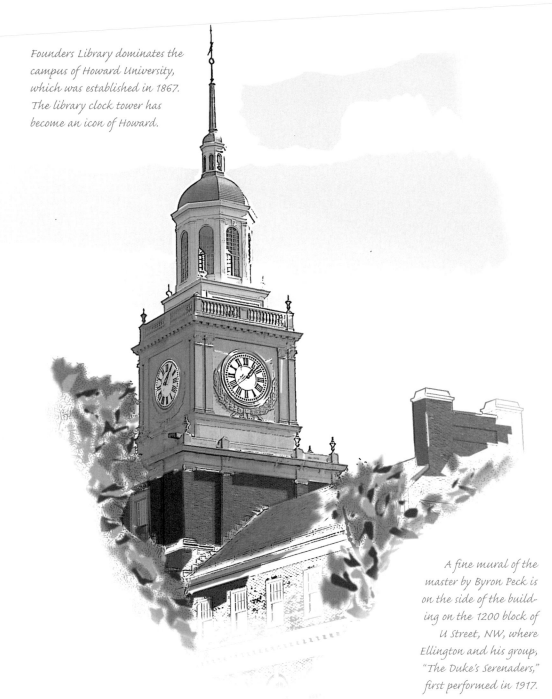

Until he moved away to seek fame and fortune, native-born Washingtonian and jazz great "Duke" Ellington (1899–1974) lived with his parents in the Shaw neighborhood, latterly at this house in T Street, NW.

A fine mural of the master by Byron Peck is on the side of the building on the 1200 block of U Street, NW, where Ellington and his group, "The Duke's Serenaders," first performed in 1917.

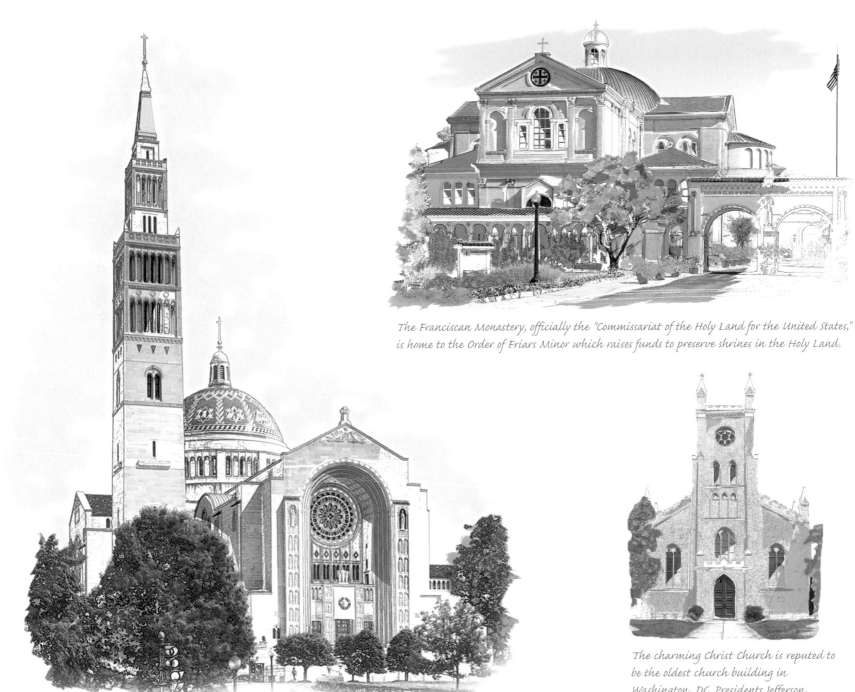

The Franciscan Monastery, officially the "Commissariat of the Holy Land for the United States," is home to the Order of Friars Minor which raises funds to preserve shrines in the Holy Land.

The charming Christ Church is reputed to be the oldest church building in Washington, DC. Presidents Jefferson, Madison, Monroe, and John Quincy Adams all attended services here.

The largest Catholic church in the USA, the National Shrine of the Immaculate Conception, is surrounded by so many Roman Catholic institutions that the area is often referred to as "Little Rome."

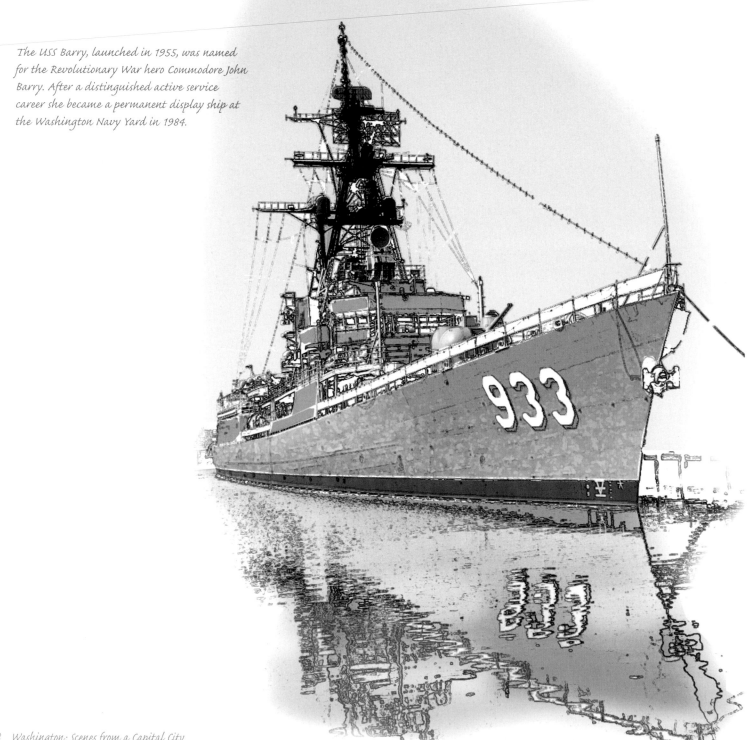

The USS Barry, launched in 1955, was named for the Revolutionary War hero Commodore John Barry. After a distinguished active service career she became a permanent display ship at the Washington Navy Yard in 1984.

The Washington Navy Yard, the oldest surviving in the United States, was largely destroyed when Washington was invaded in 1814, but the gateway by Benjamin Latrobe survived. Although considerably altered since, the gate still retains Latrobe's sense of grandeur.

The Commandant's House has housed every Marine Corps Commandant since 1805. The view is of the rear of the house from within the Marine Corps barracks compound.

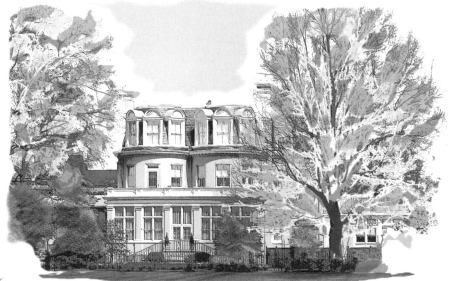

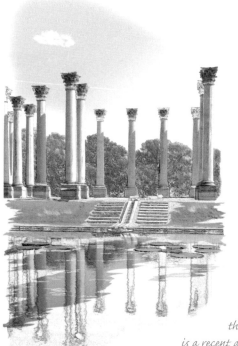

The garden of Corinthian columns that were formerly part of the Capitol is a recent addition to the US National Arboretum, one of the hidden treasures of Washington.

Anacostia Historic District has grown from Uniontown, the first suburb of Washington, incorporated in 1854 to serve workers from the Navy Yard across the river.

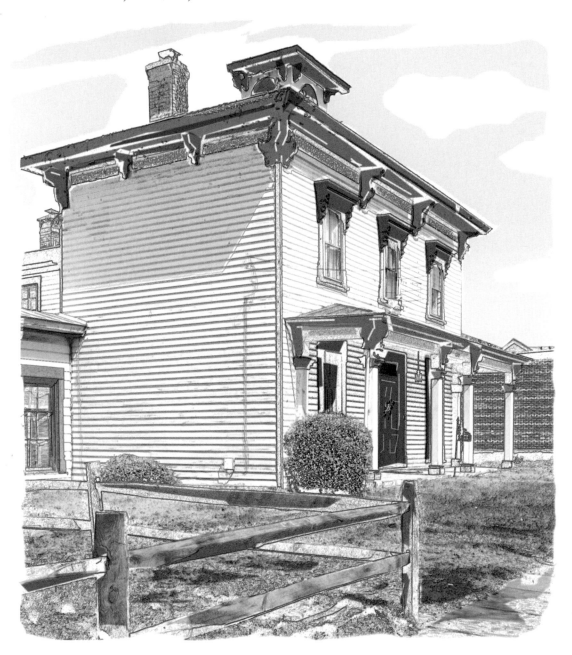

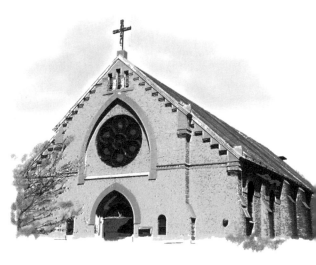

The Catholic parish church of St. Teresa of Avila was founded in 1879: the congregation at that time was largely of German, Irish and African American origin.

A feature of Old Anacostia is wood-framed houses with front porches and Italianate detail. This fine example was built about 1875.

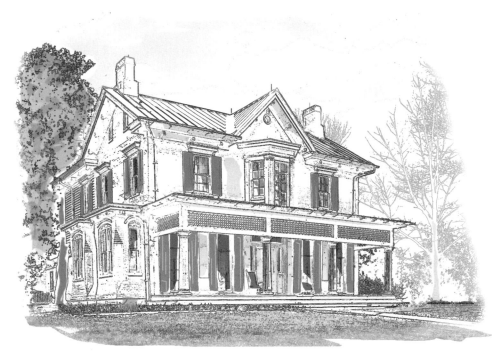

"Cedar Hill" was purchased by abolitionist leader Frederick Douglass in 1877 and he lived here with his family until his death in 1895. Magnificently sited on a hill with views across the Anacostia River to the center of Washington, the house is typical of quality homes built in what was then known as Uniontown.

Picturesque Engine House 19 on Pennsylvania Avenue, SE, was built in 1911. All of the 29 pre-WWII fire stations in the city are considered significant for their architecture.

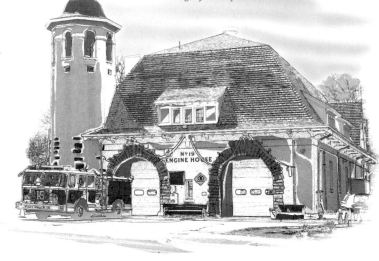

The Anacostia Community Museum is a striking but little-known part of the Smithsonian Institution. The museum is devoted to African American history and culture with particular reference to the District of Columbia and neighboring states. In 2006 a site on the Mall adjacent to the Washington Monument was selected for a new Museum of African-American History and Culture.

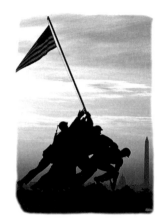

Across the Potomac

Symbolic Washington doesn't stop at the river's edge. It continues across the Potomac via Memorial Bridge into green Virginia hills now occupied by Arlington National Cemetery, a final resting place for two presidents and thousands of American military personnel dating back to Union soldiers in the Civil War. In the flatlands bordering the river stands the Pentagon, the symbolic and actual locus of American military power, and, a few miles to the south, the city of Alexandria, a thriving port town before the national capital on the other side of the river was even a dream.

Founded in 1749 and surveyed in part by none other than George Washington, then an ambitious 17-year-old surveyor's apprentice, Alexandria grew rapidly as a center of trade in tobacco and slaves. Like the Arlington hills, Alexandria became part of the 10-mile-square federal district selected by President Washington in 1791, but the union of Southern city and federal capital never really took hold. In 1846 Congress returned the territory beyond the Potomac's opposite bank, some 30 square miles in all, to the state of Virginia.

Old Town Alexandria today—so called to distinguish the original gridded blocks close to the river from the remainder of a suburban city of about 130,000 souls—retains a lot of its eighteenth-century character. Most of its warehouses and industrial plants have long since been converted into an appealing assortment of shops, art galleries and restaurants, and the old city's collection of eighteenth- and early nineteenth-century residential architecture is without compare in the Washington region.

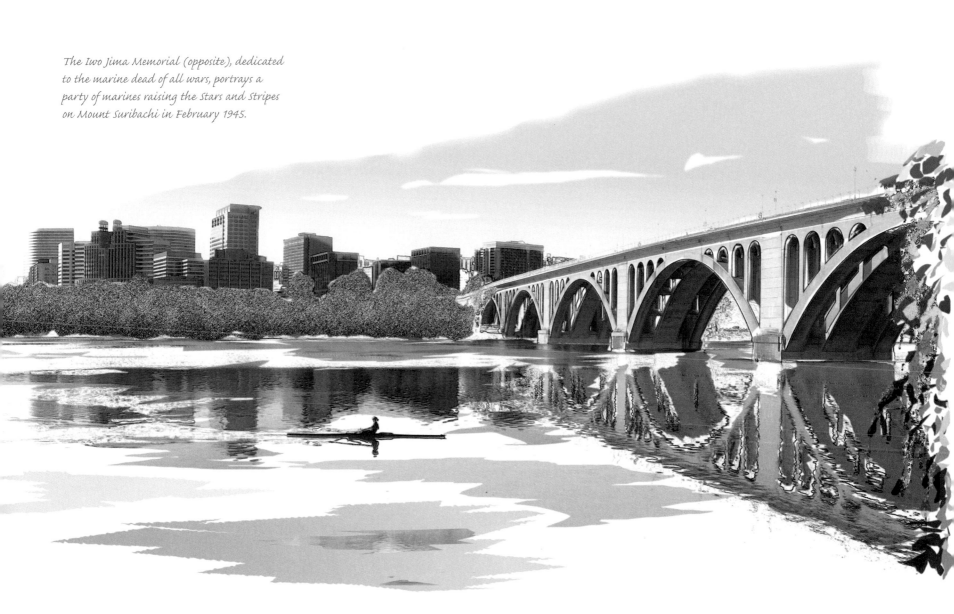

The Iwo Jima Memorial (opposite), dedicated
to the marine dead of all wars, portrays a
party of marines raising the Stars and Stripes
on Mount Suribachi in February 1945.

The finely arched Key Bridge was completed in 1923 and named for Francis Scott Key. It reaches across the Potomac to link
the bustling modern high-rise commercial neighborhood of Rosslyn on the Virginia shore with historic low-rise Georgetown
and downtown Washington.

Arlington National Cemetery is at once spectacular, sobering and a forceful reminder of the price of national security.

Acres of identical white headstones bear the names of over 300,000 veterans from every war in which the nation has been engaged.

The low-key grave of President John F. Kennedy incorporates the eternal flame, lit by Mrs. Kennedy on the day of the funeral, and a slab of slate from Cape Cod. Arlington House, in the background, was the home of General Robert E. Lee.

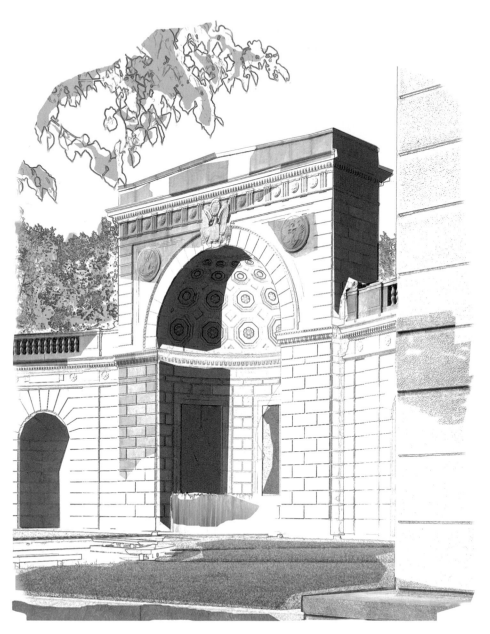

Memorial Gate, the main entrance to the cemetery, houses the Memorial to Women in Military Service for America.

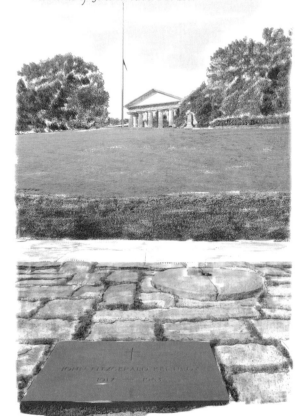

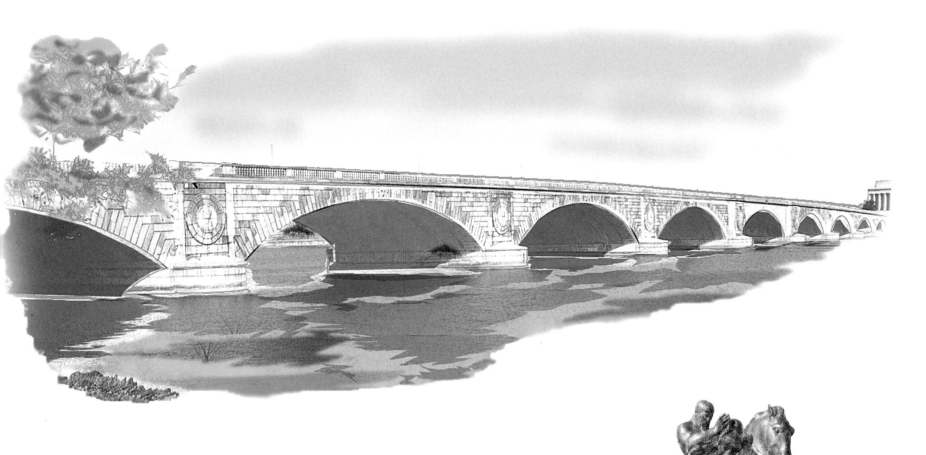

The placement of the graceful Arlington Memorial Bridge, spanning the Potomac between Lee's house (now part of Arlington National Cemetery) and the Lincoln Memorial, was conceived as a symbolic gesture reconnecting North and South. It is seen here from the Virginia bank.

Two gilded bronze equestrian statues – "The Arts of War" by Leo Friedlander – flank the entrance to the bridge.

In Old Town Alexandria, part of the original District of Columbia, many examples of beautiful mid-Georgian and Federal architecture have been preserved.

Gadsby's Tavern started life in 1752 as a small coffee house and was extended to become a hotel in 1792. It was a popular haunt of George Washington, and his last birthday was celebrated here.

The Stabler-Leadbeater Apothecary Shop was opened in 1772 by Edward Stabler and operated continuously for 150 years. It is now a museum.

Carlyle House can claim to have been the starting point for the American Revolution. It was here that General Braddock and five British governors met and proposed the Stamp Act of 1755 which lead to the struggle against taxation without representation.

Gentry Row on Princes Street is a charming brick-paved row lined with mid-18th-century homes.

The airy Old Presbyterian Meeting House was built when the original sanctuary on this site burned down in 1835.
The Presbyterian Church in Alexandria was first organized in 1772 by a group of Scottish settlers.

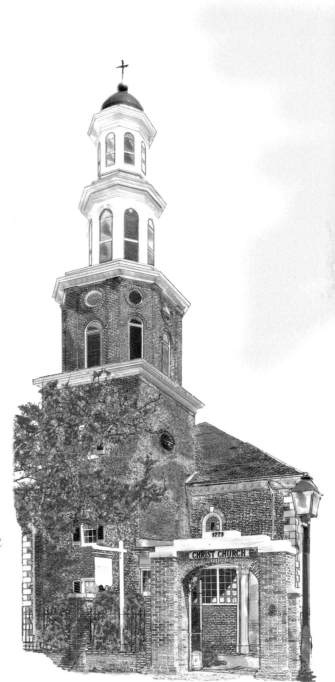

Christ Church is the oldest continually active Episcopalian church in the USA. George Washington and Robert E. Lee both worshipped here and their family pews are marked with plaques. And here, President Roosevelt and British Prime Minister Winston Churchill attended service together during World War II.

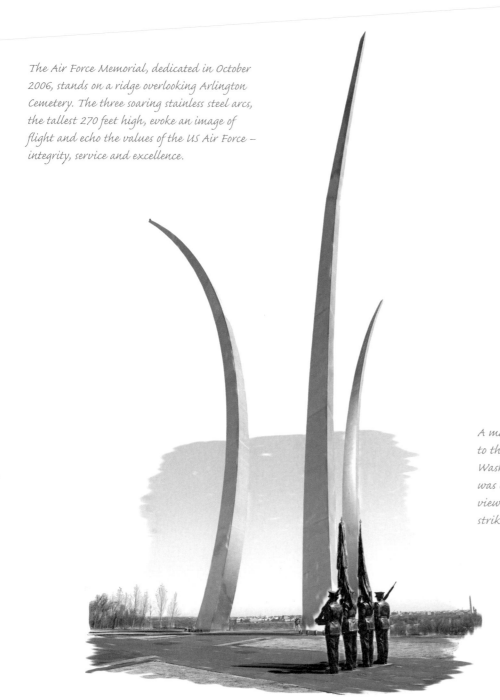

The Air Force Memorial, dedicated in October 2006, stands on a ridge overlooking Arlington Cemetery. The three soaring stainless steel arcs, the tallest 270 feet high, evoke an image of flight and echo the values of the US Air Force – integrity, service and excellence.

A major addition to the Ronald Reagan Washington National Airport was completed in 1997. It features vast expanses of glass providing views out to the Potomac River beyond the runways, and this striking 201-foot traffic control tower.

Construction on the Pentagon, headquarters of the US military, began on 11 September 1941 as war raged in Europe. Sixty years later to the day, one section of the five-sided building was hit by an aircraft hijacked by terrorists and extensively damaged. That wedge, on the opposite side of the building from the Secretary's entrance shown, was repaired and operational again less than one year after the attack.

Dulles International Airport, Washington's award-winning international gateway.

Gazetteer

HISTORIC WASHINGTON

Pages 7 and 18
The United States Capitol (1793–present)
The cornerstone of the Capitol was laid by George Washington in 1793. Construction was to continue under a series of architects including Benjamin Latrobe (1803–17), Charles Bullfinch (1819–29), and Thomas U. Walter (1851–65) with whose dome the present form emerged.

Pages 8 and 20
National Archives (1935)
Pennsylvania Avenue between Seventh & Ninth Streets, NW
The National Archives houses not only the Declaration of Independence, the Bill of Rights, and the US Constitution, all on display, but also a million file drawers of important treaties, historic documents and genealogical records. John Russell Pope's neo-classical building is the jewel of the Federal Triangle.

Pages 9 and 68
Washington National Cathedral (1907–90)
Wisconsin Avenue, NW
English architect George Frederick Bodley designed the gorgeous Gothic cathedral working with his former draughtsman, Henry Vaughan, but it underwent several modifications, in particular by Philip Frohman a Bostonian who was chief architect for 50 years. The cornerstone was laid by President Theodore Roosevelt in 1907 and the building essentially completed in 1990.

Page 11
McCormick House (1912)
3000 Massachusetts Avenue, NW
John Russell Pope's fine building was designed for Robert McCormick, a Chicago tycoon who, like many of Pope's early clients in Washington, had had a career in the diplomatic service. The Tuscan-columned entrance is derived from the Peruzzi's Palazzo Masimo in Rome. Pope went on to be one of Washington's most important architects with the Jefferson Memorial, the West Building of the National Gallery of Art, Constitution Hall and the National Archives to his credit.

Page 12
LeDroit Park (c. 1870–1900)
This subdivision is listed in the National Register of Historic Places. In the 1870s over 60 houses designed by local architect James H. McGill in romantic styles popular at the time, were built to provide spacious living outside the city. As the city grew in the 1890s, colorful row houses were added and these now dominate the area.

Page 13
Freedom Plaza (1980)
Pennsylvania Avenue between 13th & 14th Streets, NW
Designed by Robert Venturi and Denise Scott Brown as part of the Pennsylvania Avenue redevelopment plan, the plaza incorporates L'Enfant's original plan for central Washington, marked out in black-and-white stone and grass plantings.

Page 14
Treasury Building (1836–71)
Pennsylvania Avenue & 15th Street, NW
The oldest of the US Government's departmental buildings and the world's largest Greek Revival structure, the Treasury building was built, wing-by-wing, over 35 years. The original design was by Robert Mills. Mills died in 1855 and the work was continued by Thomas U. Walter who added porticos in the north, west and south façades. The choice of site by President Andrew Jackson frustrated forever Pierre L'Enfant's intention that there should be an uninterrupted view between the Capitol and the White House.

Page 15
Kennedy-Warren Apartments (1930–31, 1935, 2003)
3133 Connecticut Avenue, NW
This is perhaps the most spectacular of the several Art-Deco buildings that are a feature of this stretch of northwest Washington. The original plans, by Joseph Younger, were not all built immediately but a wing following his design was added in 1935, and another in 2003. (See also The Broadmoor, page 70)

Page 16
The Sackler Gallery for Asian Art (1987)
Independence Avenue at 10th Street, SW
The gallery's gray granite façade, enlivened with inset patterns, was chosen by architect Jean-Paul Carlhian to harmonize with its wildly different neighbors. A sister building, The National Museum of African Art, is located across the delightful Enid A. Haupt garden. The gallery was founded by Dr. Arthur M. Sackler, a New York physician, with the donation of his collection of over 1,000 items of Asian art and a gift of $4 million. Largely underground, it is joined to the Freer Gallery which also specializes in Asian art.

Page 17
Grant Memorial (1909–22)
East Mall at First Street, NW
Ulysses S. Grant, general-in-chief of the Union forces of Abraham Lincoln, is memorialized in the city's largest statuary grouping. The marble pedestal, erected in 1909, was designed by Edward P. Casey. Sculptor Henry Merwin Shrady worked for 20 years on the statuary and died two weeks before it was dedicated.

CORRIDOR OF POWER

Page 19
Supreme Court Building (1935)
First & East Capitol Streets, NE
After over a century of meeting within the US Capitol, in 1935 the Supreme Court finally moved to its own quarters, a fine neoclassical building clad in gleaming Vermont marble, designed by Cass Gilbert Jr. The magnificent bronze doors to the Court, which have 16 panels depicting the development of law, are by John Donnelly Jr.

Page 20
Folger Shakespeare Library (1928–32)
201 East Capitol Street, SE
Established in 1932 as a gift to the American people by Henry and Emily Folger, the Folger is home to the world's largest collection of Shakespeare's printed works. The library also serves as a museum devoted to the bard's life and times. Paul Cret's striking Art-Deco building is listed in the National Register of Historic Places.

Page 21
Library of Congress, Thomas Jefferson Building (1886–92)
First Street, SE
When the congressional library, founded on Thomas Jefferson's private collection, grew too large to be housed within the Capitol, it was moved to the specially built Jefferson Building. The design, by Smithmeyer and Pelz (who had recently completed Healy Hall at Georgetown University, see page 59), was based on the Paris Opera House. The interior has been said to be the most glorious in all of Washington.

Page 22
J. Edgar Hoover (FBI) Building (1963–75)
935 Pennsylvania Avenue, NW
The brutalist building designed by C. F. Murphy and Associates was one of the first to rise in the highly successful Pennsylvania Avenue revitalization program. Its poured-concrete construction, used for reasons of economy, contrasts with the traditional stone finishes of government buildings, and security considerations dictated that there be no stores on the first floor.

Page 23
Old Post Office (1892–99)
1100 Pennsylvania Avenue, NW
The original Romanesque revival design, with its distinctive 315-foot tower which can be seen from many parts of the city, is attributed to Willoughby Edbrooke, a Chicago architect who was the supervising architect in the Treasury Department in the 1890s. The building was abandoned by the Post Office in the 1930s and several times threatened with demolition. It underwent a major restoration under Arthur Cotton Moore & Associates in 1982, who opened up the central atrium to offices and shops.

Page 24
Warner Theatre (1924, 1989–92)
13th & E Streets, NW
The Warner Theatre was first opened (as the Earle) in 1924. In the early 1970s, as with much of downtown Washington, it fell into disrepair and finally closed for three years while a block-long office building incorporating the theater was redeveloped. Overall design was by James Ingo Freed of Pei, Cobb, Freed & Partners. Shalom Baranes Associates handled the renovation of the Warner Theatre. It re-opened in 1992.

Willard Inter-Continental Hotel (1901–04, 1979–86)
1401 Pennsylvania Avenue, NW
Henry Willard, who acquired a hotel on the site in 1850, gave his name to the present 1904 beaux-arts building, designed by Henry Hardenbergh, architect of New York's Plaza Hotel. After the riots that followed Martin Luther King Jr.'s assassination the area declined and the Willard with it. It was rescued as part of the sterling work of the Pennsylvania Avenue Development Corporation. The west wing was added, following a concept by Hardy Holzman Pfeiffer Associates executed by Vlastimil Koubek, and the new 340-room hotel opened in 1986.

Page 25
Ronald Reagan Building & International Trade Center (1998)
1300 Pennsylvania Avenue, NW
The last major construction in the Federal Triangle was designed by James Ingo Freed. The modern interior of the second-largest federal building (after the Pentagon) houses government offices, private businesses including retail outlets and restaurants, and a memorial to President Woodrow Wilson.

Page 26
Department of Commerce Building (1926–32)
14th Street between E Street and Constitution Avenue, NW
Architect Louis Ayres of York and Sawyer, a New York firm which earned a reputation for monumental Beaux Arts buildings in its home town, kept a sense of scale in this massive structure by dividing its long façades into distinct and distinctive blocks, built round six interior courtyards.

Page 27
The White House (1792–1803)
1600 Pennsylvania Avenue, NW
Begun in 1792, the Executive Mansion was designed by James Hoban, an Irish architect from Charleston, SC. President John Adams and his wife were the first residents. The building was torched in 1814 by British troops but a rainstorm saved it from total destruction. During the restoration the charred timbers were covered with white paint and it is said by some that this was the origin of its name—made official by Theodore Roosevelt in 1901.

Tayloe House (1828)
21 Madison Place, NW
Built by Benjamin Ogle Tayloe (son of John Tayloe who owned The Octagon, page 41), this charming yellow house with its lacy wrought-iron balcony has been successfully absorbed into the modern US Court of Claims designed by John Carl Warnecke (1968). Tayloe, who wrote a book on his observations on Lafayette Square, is also noteworthy for his bequest of the iconic 1796 portrait of George Washington by Gilbert Stuart to the Corcoran Gallery.

Page 28
Renwick Gallery (1859–61)
Pennsylvania Avenue & 17th Street, NW
The gallery housed the collection of William Wilson Corcoran until this was moved in 1897 to the Corcoran Gallery of Art (page 39). It was renamed for its architect, James Renwick Jr., who took his inspiration from the French Second Empire style.

The Old Executive Office Building (1871–88)
Pennsylvania Avenue & 17th Street, NW
The flamboyant design of this massive building by Alfred B. Mullet was influenced by the Renwick Gallery sited opposite on Pennsylvania Avenue. When finished it was the world's largest office building. It initially housed the State, War and Navy departments. Today it provides space for government and White House staff.

Page 29
St. John's Church (1815)
1525 H Street, NW
Benjamin Latrobe's original design was a church in the form of a Greek cross with a small cupola above the square nave. The steeple was added in 1822 and the nave was extended during remodelling by James Renwick in 1883. The cupola is gilded with 23-karat gold leaf.

The Hay-Adams Hotel (1927)
800 16th Street, NW
This hotel, overlooking Lafayette Park, was built on the site of two houses designed for two Harvard friends, John Hay and Henry Adams. Developer Harry Wardman bought the houses and had his favorite architect, Mihran Mesrobian, design this fine Renaissance building which was recently restored to its original grandeur.

Decatur House (1818)
748 Jackson Place, NW
Shortly after Thomas Jefferson gave up part of the White House grounds to create the public area in front (later to be named after Revolutionary War hero Major-General Marquis de Lafayette) the first of the mansions that were to line the square was built for Commodore Stephen Decatur to a design by Benjamin Latrobe. It is the last of Latrobe's city houses in America to survive.

MALL, MONUMENTS and MUSEUMS

Page 31
Washington National Monument (1848–84)
Washington's most prominent landmark is the centerpiece of the Mall, and at over 555 feet was, at its completion, the tallest structure in the world. The original design, by Robert Mills, was greatly altered during construction to conform to the classical proportions of an obelisk. The cornerstone was laid on July 4, 1848, but construction was halted for nearly 25 years due to lack of funds and the Civil War. A difference in shading of the marble at about 150 feet marks where construction resumed in 1880. The monument was opened to the public in 1888.

Page 32
The Arts & Industries Building (1879–81)
900 Jefferson Drive, SW
Built as a National Museum the building comprises a series of massive trussed halls with meandering iron balconies and is elaborately finished in polychrome brick. The unmistakably Victorian design was by Adolph Cluss and Paul Schulze, with input from Montgomery Meigs. A major restoration in 1976 was led by Hugh Newell Jacobsen.

Pages 32 and 33
The Smithsonian Building (1855)
Jefferson Drive between Ninth & 12th Streets, SW
This building, popularly known as "The Castle", was designed by James Renwick in Gothic Revival style and built in red Seneca sandstone. It was the first of many museum buildings now owned by the Smithsonian Institution.

Page 34
The National Air and Space Museum (1976)
Independence Avenue at Sixth Street, SW
The soaring structure of glass and granite blocks, designed by Gyo Obata of Hellmuth, Obata, and Kassabaum, has over 200,000 square feet of space devoted to everything man-made that travels above us.

Page 35
Hirshhorn Museum of Modern Art (1974)
Independence Avenue at Seventh Street, SW
This huge reinforced-concrete three-story hollow cylinder, standing on four piers, was designed by Gordon Bunshaft of Skidmore, Owings and Merrill. The cylindrical form was designed to maximize wall space and the absence of exterior windows minimizes the risk of sun damage to the art.

National Museum of the American Indian
Fourth Street & Independence Avenue, SW
The museum design was by Canadian Native American architect Douglas Cardinal. Construction of the 250,000 square foot building, by the Bethesda-based Clark Construction Group, started in September 1999 and it was opened on 21 September 2004.

Page 36
The Lincoln Memorial (1914–22)
West Potomac Park at 23rd Street, NW
The design of Henry Bacon's memorial to the 16th president was loosely based on the Parthenon, but with its squared and recessed roof and entrance on the long façade it has its own style. The colonnade of 36 Doric columns which surrounds it symbolizes the 36 States of the Union when Lincoln was elected. Daniel Chester French's wonderful statue within is in perfect harmony with the surrounding architecture.

The United States Holocaust Memorial Museum (1993)
Raoul Wallenberg Place, SW
Architect James Ingo Freed of Pei Cobb Freed & Partners visited a number of Holocaust sites to examine structures and materials for his design. The result is a building which brutally and appropriately refers to the history within.

Page 37
The National Gallery of Art—East Building (1978)
Constitution Avenue, NW
Built to house its collection of 20th-century European and American art, I. M. Pei's addition to the National Gallery is a brilliant response to an awkward site on the triangle where Pennsylvania Avenue merges with the Mall. Although the design pays no homage to the West Building (to which it is connected by a tunnel) a link was made by building the East Building of the same Tennessee marble, cut in blocks of the same size.

The National Gallery of Art—West Building (1936–41)
Constitution Avenue, NW
The National Gallery's original building, now the West Building, was designed by John Russell Pope, who used the Pantheon in Rome as his inspiration for the central rotunda—a source he also employed for the Jefferson Memorial (page 42). Keyes Condon Florance Architects renovated the interior to good effect in 1983–85.

Page 38
The John F. Kennedy Center for the Performing Arts (1971)
2700 F Street, NW
Designed by Edward Durrell Stone, the center was dedicated by Congress to the memory of the 35th

president who had been an enthusiastic supporter of the project.

Page 39
Constitution Hall (1929)
18th & D Streets, NW
The cornerstone of John Russell Pope's Alabama-limestone-clad masterpiece of Roman form was laid by Mrs. Calvin Coolidge on October 30, 1928, using the trowel with which George Washington had laid the cornerstone at the Capitol in 1793. The Hall is owned by the Daughters of the American Revolution. The National Symphony was founded at the Hall in 1930 and called it home for 41 years.

Corcoran Gallery of Art (1897)
17th Street & New York Avenue, NW
This imposing beaux-arts construction, designed by Ernest Flagg, was built in 1897 when the gallery outgrew its original home, now the Renwick Gallery. It was extended in 1928 with a fine West Wing by Charles Platt & Waddy Wood. A proposal for a further extension, to a controversial design by Frank O. Gehry, was dropped in 2005.

Page 40
The World War II Memorial
17th Street, NW between Constitution and Independence Avenues
The memorial honors the 16 million who served in the armed forces of the US in WWII and the more than 400,000 who died. Architect Friedrich St.Florian's design, combining classical and modernist styles of architecture, was chosen from over 400 entries in a nationwide competition. Architect Raymond Kaskey (also responsible for the National Law Enforcement Officers memorial (see page 46)) created all the sculptures in the memorial. Two-thirds of the 7.4 acre memorial site is composed of landscaping.

The Vietnam Veterans Memorial (1982)
The Mall near 21st Street, NW
The brilliant design by a 21-year-old architecture student at Yale, Maya Lin, won a competition in which there were over 1,400 entries. It comprises two triangular cuts in the earth, meeting at 125 degrees and lined with black granite slabs bearing the names of over 58,000 Americans who died in the conflict.

District of Columbia World War I Memorial (1931)
West Potomac Park
This sadly neglected monument honors the men and women of the District of Columbia who served in WWI and is inscribed with the names of 499 who died in the conflict. The circular marble Doric bandstand, designed by local architect Frederick H. Brooke, can accommodate an 80-piece band.

Page 41
The American Red Cross National Headquarters (1915–17)
17th & D Streets, NW
Designed by New York architects Trowbridge & Livingston, this white-marble-faced Classical Revival building was conceived as a memorial to the "heroic women of the Civil War" from both North and South. It was listed on the National Register of Historic Places in 1966.

The Octagon Building (1800)
1799 New York Avenue, NW
Designed by William Thornton, architect of the Capitol, as a townhouse for Colonel John Tayloe III, a Virginia plantation owner, The Octagon was used by President James Madison after the White House was burned in 1814. Sold by Tayloe in 1855, and for a while a girl's school, the house was badly neglected in the later 19th century. In 1899 it was bought by the American Institute of Architects and for 50 years used as their headquarters before the organization moved into the modern building which now frames it.

Page 42
The Jefferson Memorial (1939–43)
The Tidal Basin
The memorial was opened by President Franklin D. Roosevelt in 1943 on a site formed from soil dredged from the Potomac River. John Russell Pope's last design, it was inspired by the Pantheon in Rome (which Jefferson himself had used in designing his University of Virginia library building) but is said also to owe a debt to pavilions erected in English country gardens in the 18th century, specifically one by William Evans at Stowe in Buckinghamshire.

Pages 43 and 31
Franklin Delano Roosevelt Memorial (1997)
West Potomac Park
The FDR Memorial comprises a series of four outdoor galleries—each commemorating one of FDR's terms in office—marked by sculptures recalling the history of the times, cascading water, quiet pools, ornamental tree plantings, and quotations from FDR carved in granite. The design was by landscape architect Lawrence Halprin, with sculptures and carvings by Leonard Baskin, Neil Estern, Robert Graham, Tom Hardy, George Segal and John Benson.

DOWNTOWN and GEORGETOWN

Page 45
The Washington Convention Center (2003)
Mount Vernon Place, NW
The design team was a joint venture of Thompson, Ventulett and Stainback Associates of Atlanta and two local architectural firms, Devrouax & Purnell and Mariani Architects. They minimized the bulk of the Center by dividing it into three parts with sidewalks and streets running through, by placing 40% of the floor area underground, and by varying roof heights to match the feel of existing structures in the historic neighborhood in which it is built.

Page 46
The National Building Museum (1882–87, 1985)
Fourth & F Streets NW
Built to house the staff administering pensions for Civil War veterans, the former Old Pension Building was designed by General Montgomery C. Meigs following the style of Michelangelo's Palazzo Farnese in Rome. The three-foot-tall, 1,200-foot-long terracotta frieze which encircles the building was sculpted by Casper Bulberi and depicts life in the Union forces during the Civil War. The Great Hall, 316 feet long and 159 feet high, is dominated by enormous brick-built Corinthian columns painted to resemble Siena marble.

Page 47
Chinatown Gateway (1986)
H Street at Seventh Street, NW
Alfred H. Liu's design is based on Qing Dynasty (1649–1911) architecture. The construction combines traditional wooden structures in the seven roofs and 300 painted dragons with a steel and concrete base.

DC Metro (1969–2001)
Washington was late to get a subway and the initial 100-mile system, first opened in 1976, was not completed until 2001. The system now carries 700,000 passengers each weekday. The spacious vaulted stations were designed by architect Harry Weese who toured systems in Europe and Japan for ideas.

The City Museum (1903, 2003)
Mount Vernon Square
Built with a donation from Andrew Carnegie to house the Washington Public Library, this beaux-arts style building clad in Vermont marble, was designed by New York architects Ackerman and Ross. Dedicated by President Theodore Roosevelt in 1903, it served as the headquarters of the DC library system until 1970. In 1999 Congress appropriated funds for the restoration of the building which was reopened as the City Museum on May 16, 2003. The museum's design team included local architects Devrouax & Purnell and RKK&G of New York.

Page 48
Martin Luther King Jr. Memorial Library (1972)
Ninth & G Streets, NW
The harmoniously proportioned mass of the flagship of DC's public library system was one of the last buildings designed by Ludwig Mies van der Rohe (1886–1969) and is the only example in the city. With his "less is more" philosophy, van der Mies created architecture of material honesty and structural integrity, exemplified in the Seagram Building in New York and, on a more modest scale, with this fine library.

PEPCO Building (2002)
Ninth Street at G Street, NW
Washington architects Devrouax & Purnell were charged with designing a downtown headquarters for Washington's electricity utility. The result is an impressive structure with a dynamic wall of glass, curving gently away from the sidewalk, that successfully hides the volume and utilitarian nature of the building and fits gracefully into the heart of the historic downtown district.

National Museum of American Art (1836–67)
F & G Streets between Seventh & Ninth Streets, NW
The former National Patent Office is one of the finest public buildings in Washington. The massive Greek Revival style structure took over 30 years to complete and is dominated by Doric porticos which are attributed to Robert Mills. It was renovated in 1968 to house the Smithsonian's National Museum

of American Art and the National Portrait Gallery. After a six-year renovation the museums reopened in July 2006. An undulating glass canopy enclosing the interior courtyard is set to open in November 2007. It was designed by the British architect Norman Foster, winner in 1999 of the top honor for architects, the Pritzker Prize.

Page 49
Verizon Center, formerly MCI Center (1997)
601 F Street, NW
The brainchild of Abe Pollin, owner of Washington's professional basketball and hockey teams, this modern arena manages to fit surprisingly harmoniously into its historic neighborhood by maintaining a low profile (two stories are below grade and the roof is arched) and the use of varied materials and glass. Design was by Kansas City-based architects Ellerbe Becket, with Washington firms KCF–SHG Architects, and Devrouax & Purnell, Architects.

The International Spy Museum (1875–2002)
800 F Street, NW
Construction of the museum called for the restoration of an entire city block in the historic Penn Quarter, including the LeDroit Building at the corner of Eighth and F Streets, one of the oldest remaining office buildings in the city. Designed in 1875 by James H. McGill, the four-story brick-and-wood structure is an attractive example of the Italianate style with its generous windows, columns and fine details. Over the years the building has housed small businesses, jewelers, merchants, and artists' studios.

Page 50
Ford's Theatre (1863)
511 10th Street, NW
Baltimore impresario John Ford built this theater, designed by James J. Gifford, in 1863. It was enjoying great success until, on 14 April 1865, President Abraham Lincoln was assassinated here whilst watching a performance. The theater was closed, sold to the federal government, and for nearly a century used as offices or for storage. In 1968 it was restored and reopened as a museum and a working theater, with its original décor. It is run by the National Park Service.

Page 51
Union Station (1903–08)
Massachusetts Avenue & First Street, NE
Architect Daniel Burnham's spendid marble-sheathed beaux-arts building is a consequence of the McMillan Commission's 1901 plan for Washington's monumental center and its happy decision to remove the railroad tracks and station sited on the Mall. The symmetrical exterior design borrows from Roman triumphal arches, and the Grand Concourse is based on Rome's Baths of Diocletian.

Page 52
The Homer Building (1913, 1990)
601 13th Street, NW
The original Homer Building was designed by local architect Appleton Prentiss Clark Jr. in 1913 as a four-story beaux-arts structure. In 1983 it was designated as an historic landmark, but by this time had fallen into disrepair. The building was restored in 1990 by the developer Akridge to a design by Shalom Baranes Associates, who retained the terracotta façade and seamlessly raised the building to 12 stories, centered on a full-height atrium.

Former Greyhound Bus Station (1940)
1100 New York Avenue, NW
The Art-Deco building, designed by William S. Arrasmith, served as a bus station from its opening in 1940 until the 1980s. It has been preserved and neatly incorporated into the Manulife Real Estate Building (1991, Florance Eichbaum Esocoff King, architects) that serves as a backdrop.

Page 53
The Franklin School (1869)
13th & K Streets, NW
Designed by Adolph Cluss—later to design the Arts and Industries Building (page 32) and Eastern Market (page 75)—the school was opened in 1869, part of an effort to upgrade the public school facilities in the capital. The octagonal towers (there is one at each corner of the building) are not simply ornamentation: they house ventilation shafts.

Page 54
The World Bank (Main Complex) (1990–97)
1818 H Street, NW
When founded in 1944 the World Bank was located in a former federal government building on this site. Its new headquarters building, occupying a full city block off Pennsylvania Avenue, was designed by Kohn Pedersen Fox with local architect Kress Cox Associates. The uncompromisingly modern structure incorporated two existing buildings.

Page 55
Turning Corners
1225 Eye Street, NW (1985)
Designed for developer John Akridge by architect Byron B. Black of the Washington-based Weihe Design Group.
2401 Pennsylvania Avenue, NW (1990)
Architect Phil Esocoff of Keyes Condon Florance was in charge of the design of this award-winning mixed-use building.
Presidential Plaza (1986) 900 19th Street, NW
Architects Keyes Condon Florance used a clock tower to anchor the corner of this Art-Deco-style building in which polished light and dark granite mark the line of each floor.

Page 56
Vigilant Fire Company (Organized 1817)
1066 Wisconsin Avenue, NW
The only remaining pre-Civil War firehouse in the city is that of the Vigilant Fire Company, organized as a volunteer force in 1817. It is typical of that era: simple two-story buildings topped with a belfry. It is listed on the National Register of Historic Places and is now used as a restaurant.

Page 57
House of Sweden
2900 K Street, NW
In designing this elegantly modern building the Swedish architects Gert Wingårdh and Tomas Hansen of Wingårdh Arkitektkontor made extensive use of blonde Swedish maple, light stone, and glass to take full advantage of the prime waterfront site and its fine vistas. The interior sculptural detail of the 70,000 square foot diplomatic headquarters is by Ingegerd Råman.

Washington Harbor (1986)
3000 K Street, NW
This large multi-styled mixed-use complex which brings Georgetown to the Potomac was designed by Washington architect Arthur Cotton Moore. Plans have been drawn up for a shoreline promenade that would continue pedestrian access from the harbor to the west as far as Key Bridge and to the southeast to the Water Gate steps, beyond the Kennedy Center.

Page 59
Georgetown University—Healy Hall (1879)
37th Street, NW
Designed by Smithmeyer and Pelz, later architects of the Library of Congress' Thomas Jefferson Building (page 21). Healy Hall was built in the Flemish Renaissance style and is on the National Register of Historic Places. The clock tower rises 200 feet.

Page 60
Tudor Place (1816)
1644 31st Street, NW
This wonderful neoclassical house was designed by William Thornton (first architect of the Capitol and architect of The Octagon) for Martha Custis Peter—granddaughter of Martha Washington—and her husband, Thomas Peter. It has been described as his masterpiece. The family lived in it until 1983.

Page 61
Dumbarton Oaks (1801)
3101 R Street, NW
The original redbrick Federal style mansion, was built by its first owner, William Dorsey. After many owners and many changes, in 1920 it was purchased by Robert Woods Bliss who enlarged the house and had landscape architect Beatrix Farrand develop the home gardens into a masterpiece of terraced landscaping. In 1940 most of the property was conveyed to Harvard University.

UPTOWN

Page 62
Dupont Memorial Fountain (1921)
Dupont Circle, NW
In 1921 the Du Pont family replaced a small bronze statue of Admiral Samuel Francis du Pont, which had been erected by Congress in the center of the Circle, with a marble fountain by architect Henry Bacon and sculptor Daniel Chester French, the team responsible for the Lincoln Memorial.

Page 63
The Cosmos Club (Towsend House, 1901)
2121 Massachusetts Avenue, NW
The Cosmos Club has maintained glorious Townsend House largely as built for Richard and Mary Townsend, who had made their fortune from railroad development. The design, by New York architects Carrere & Hastings, was based on Le Petit Trianon, the Versailles house built for Mme de Pompadour in 1761 and considered among the most perfect buildings in France.

Page 64

Anderson House (1902–05)
2118 Massachusetts Avenue, NW
This fine beaux-arts mansion was designed by Boston architects Little and Browne for career diplomat Larz Anderson III and his writer wife.

Patterson House (1902)
Dupont Circle, NW
One of only two survivors of the mansions which rimmed Dupont Circle before WWII, Patterson House was built in 1902 for Robert Patterson, editor of the *Chicago Tribune* to a design by McKim, Mead and White.

Page 65

The Textile Museum (1912)
2320 S Street, NW
John Russell Pope, most of whose work in Washington is more monumental, designed this house for George Myers in 1912. Its terraced garden can be seen from the street through the Doric-columned porch.

Turkish Residency (Everett House, 1915)
1606 23rd Street, NW
Architect George Oakley Totten Jr., a prolific and versatile Washingtonian, combined Franco-Italian styles with beaux-arts elements to produce this very attractive building for Edward Everett in 1915. Like many of Totten's commissions it became an embassy and is now the Turkish ambassador's residence. A major renovation was completed in August 2006.

Page 66

The Islamic Center (1949)
2551 Massachusetts Avenue, NW
Islamic nations with embassies in Washington collaborated to found this religious and cultural center, designed by Mario Rossi. A mosque with a 160-foot minaret is an independent structure in the courtyard of the building, which is furnished with fine craftswork by Middle Eastern artisans. Its library holds approximately 4,000 titles, from the end of the 18th century to the present.

British Embassy (1927–28)
3100 Massachusetts Avenue, NW
For his design for the new British embassy, formerly on Dupont Circle, the great English architect, Sir Edwin Lutyens, adopted a style distinctly reminiscent of American colonial architecture. The Churchill statue is by William McVey (1902–95).

Page 67

Italian Embassy (1996–2000)
3000 Whitehaven Street, NW
The dramatic four-story building by architect Piero Sartogo of Rome, with Leo A. Daly as architect of record, was designed to be "somehow Italian" and compatible with its surroundings. The cantilevered copper eaves recall those of Renaissance palazzi, and the façades are faced with 42,000 pieces of Italian Pietra Rosa di Asiago pre-cut in Italy.

Page 68

Washington National Cathedral (1907–90)
Massachusetts & Wisconsin Avenues, NW
The top of the Gloria in Excelcis crossing tower of this glorious cathedral is the highest point in Washington, rising to 330 feet above Mount St. Alban. An English architect, George Frederick Bodley, designed the cathedral, working with his former draughtsman—by now a naturalized American—Henry Vaughan, but the design was modified several times, in particular by Philip Frohman, a Bostonian who was chief architect for 50 years.

Page 69

The Taft Bridge (1897–1907)
Connecticut Avenue, NW
At the time of its construction the Taft Bridge, designed by George S. Mason, was the largest reinforced concrete bridge in the world. Four concrete lions guard the ends of the bridge. The originals were sculpted by Roland Hinton Perry who had earlier made the Neptune Fountain in front of the Jefferson Building of the Library of Congress.

Page 70

The Broadmoor Apartments (1929)
3601 Connecticut Avenue, NW
The second major block on Connecticut Avenue designed by Joseph Abel, this one in a Gothic Revival style, the Broadmoor was named for the famous luxury resort hotel in Colorado Springs, CO.

Page 71

INTELSAT Headquarters Building (1987)
3400 International Drive, NW
This sprawling space-age glass and concrete structure was designed for INTELSAT—a company that owns and operates global satellite communications—by the Australian firm, John Andrews International Ltd.

Page 73

The Kreeger Museum (1967)
2401 Foxhall Road, NW
David Lloyd Kreeger and his wife, Carmen, retained Philip Johnson to create a home, concert space, and gallery for their collection of paintings and sculpture from the 1850s to the 1970s. The post-modern structure which resulted draws on Greek and Byzantine idioms and above all, the style of a Roman villa.

EAST of ROCK CREEK

Page 74

The Lincoln Theater (1921)
1215 U Street, NW
In 1994 the stunningly restored Lincoln Theater reopened after a long closure and is once again the focus of cultural life in the Shaw area. The theater was built in 1921 by pioneering theater magnate Harry M. Crandall, to a design by Reginald M. Geare.

Page 75

Eastern Market (1873)
Seventh & C Streets, SE
The heart of the Capitol Hill community, this is the last functioning market of several which provided fresh produce for Washingtonians in the 19th century. It was designed by Adolph Cluss, whose considerable work included the even more flamboyant Arts and Industries Building and the Franklin School (pages 32 and 53).

Ben's Chili Bowl (1958)
1213 U Street, NW
Located next to the Lincoln Theater, Ben's is a nationally renowned cafe, locally known as a meeting place for Howard students, musicians and the DC political establishment. The family business was opened in 1958 in what had been Washington's first silent movie theater—the Minnehaha, built in 1909—and later a pool hall.

Page 76

Howard University—Founders Library (1930s)
Howard Place, NW
Founders Library dominates the campus of Howard University, which was founded in 1867 as a seminary for training black men for the ministry and has grown to become a distinguished university. The library, designed by Louis Fry, houses the country's largest collection of books on black history and culture.

Page 77

National Shrine of the Immaculate Conception (1919–59)
Michigan Avenue & Fourth Street, NE
In spite of its size the Shrine's smooth Indiana-limestone walls and clean lines give it an airy grace that sets off its stunning gold, blue and red mosaic decoration. Architect Charles D. Maginnis' Neo-Byzantine design includes both a huge dome and a 329-foot carillon, just a foot shorter than the central tower of the National Cathedral.

Franciscan Monastery (1899)
1400 Quincy Street, NE
The Italian Renaissance building, set in 44 acres of woodland and magnificent gardens, was designed by Aristides Leonori.

Christ Church (1817)
620 G Street, SE
Reputed to be the oldest church building in Washington, DC, Christ Church has been variously attributed to Benjamin Latrobe and to Robert Alexander, a contractor who worked for Latrobe. Whoever did the original design, the present fine Gothic Revival structure we see today is the result of many subsequent additions and alterations.

Page 78

***USS Barry* (launched 1955)**
Pier 2, Washington Navy Yard
The 4,000-ton Forrest Sherman Class destroyer, USS Barry, was commissioned in 1956 and served in actions off Lebanon, Cuba and Vietnam. In the 1970s the Barry was homeported in Athens, Greece. Decommissioned in 1982 she is now a permanent display ship.

Page 79

Latrobe Gate (1805–06)
Washington Navy Yard, Eighth & M Streets, SE
The original planning and design of the Navy Yard was by the prolific Benjamin Latrobe. Much of the yard was destroyed when the British invaded Washington in 1814, some by the defenders to avoid it being captured and more by the occupying forces, but the Greek Revival style gateway survived. Considerably altered in 1823 and then in 1880–81, it is protected as a Category II landmark building.

The US National Arboretum (approved by Congress, 1927)
3501 New York Avenue, NE
This 444-acre spread of trees, shrubs and gardens on rolling land extends to the banks of the Anacostia River. It includes a renowned bonsai collection and is an important educational and research center. The Capitol Columns garden, landscaped by Russell Page, was added in 1990. The Corinthian columns, designed by Benjamin Latrobe, were removed from the east front of the Capitol during extensions in the 1950s.

The Commandant's House, Marine Corps Barracks (1805)
801 G Street, SE
When originally designed by George Hadfield in 1805 the house did not have the mansard roof which was added in one of its several remodellings. The residence was retained when the rest of the barracks was replaced in 1902–06.

Page 80
House, Old Anacostia (c. 1875)
1312 U Street, SE
The frame houses in Anacostia—many of which are over 140 years old—are unique in a city where most historical structures are built of brick.

St. Teresa of Avila Church (1879)
13th & V Streets, SE
The Gothic Revival building, designed by E. Francis Baldwin, a Baltimore architect, is built of brick and limestone, now covered with stucco.

Page 81
Cedar Hill—The Frederick Douglass House (c. 1855)
141 W Street, SE
The famed abolitionist leader (1818–1895) purchased this 21-room house—built by John Van Hook, an original developer of the area—in 1877 and lived here with his family until his death. It has been restored to its original form and holds many mementos given to Douglass during his sojourn. The house is maintained by the National Park Service and is open to the public throughout the year.

The Anacostia Community Museum (1987–2001)
1901 Fort Place, SE
The original Anacostia Neighborhood Museum opened in the Carver Theater in Anacostia in 1967. Its new site was developed by the architectural firm of Keyes Condon Florance in 1987 and

upgraded and expanded in 2001 by Wishnewski Blair Associates and architrave, p.c. architects, who designed the new front façade.

Engine House 19 (1911)
2813 Pennsylvania Avenue, SE
This picturesque Arts and Crafts style building, designed by Averill, Hall and Adams, has functioned as a fire station throughout its history.

ACROSS the POTOMAC

Page 82
Iwo Jima Memorial (1954)
N. Meade Street, Arlington
The US Marine Corps War Memorial is a stunning 78-foot-high sculpture by Felix de Weldon based on the prize-winning photograph by Joe Rosenthal of marines raising the Stars and Stripes on Mount Suribachi in February 1945.

Page 83
Key Bridge (1917–23)
Between Georgetown and Rosslyn
The Francis Scott Key Bridge—named for the composer of "The Star Spangled Banner," whose house had stood near the DC end of the bridge—links Georgetown to the modern high-rise development of Rosslyn on the Virginia shore. The gracefully arched reinforced concrete bridge was designed by architect Nathan C. Wyeth. It replaced an 1834 aqueduct bridge, the pilings of which can still be seen, which brought canal boats across the Potomac.

Page 84
Arlington National Cemetery (established 1864)
The green slopes of the 612-acre cemetery were once part of the estate of Martha Washington's adopted grandson, George Washington Parke Custis, whose daughter, Mary Ann, married Confederate General Robert E. Lee in 1831.
Memorial Gate (1926–32) is the main entrance. Designed—along with Memorial Bridge and Memorial Drive—by McKim, Mead and White, it was modified in 1997 to house the Memorial to Women in Military Service for America.
The grave of President John F. Kennedy (1967) was designed by John Carl Warnecke & Associates.
Arlington House, a Georgian Revival building, was started in 1802 by George Custis and developed in 1818 by George Hadfield who had been architect to the Capitol. For 30 years it was the home of Confederate General Robert E. Lee (1807–1870).

Page 85
Arlington Memorial Bridge (1926–32)
The design of the 2,000-foot granite-faced bridge, by McKim, Mead and White, is said to have been inspired by Roman aqueducts. Although part of the original design for the bridge, Leo Friedlander's equestian groupings were not cast and installed until 1951.

Page 86
Gadsby's Tavern and Museum (1752)
134 N. Royal Street, Alexandria
Originally a small coffee house opened in 1752, and extended to become a hotel in 1792 and named for innkeeper John Gadsby, this fine Georgian building has been completely restored and contains much of the original furniture, china and silverware.

Carlyle House (1751–52)
121 N. Fairfax Street, Alexandria
This fine manor was designed by John Ariss and built by John Carlyle, a Scotsman who came to America in 1741 as the representative of an English merchant and became Alexandria's leading citizen. After over a century and a half of use—as a Civil War hospital, a hotel and private home—it was restored in 1976 and opened to the public as a museum.

Stabler-Leadbeater Apothecary Shop (1772)
105–7 S. Fairfax Street, Alexandria
The shop was opened in 1772 by Edward Stabler. His daughter, Mary, married pharmacist John Leadbeater who became the sole proprietor in 1852. The shop operated continuously until it closed during the Great Depression. Since 1939 it has been a museum showing a large collection of original prescriptions, early medical wares, hand-blown glassware and period furniture.

Page 87
The Old Presbyterian Meeting House (1835–37)
South Fairfax Street, Alexandria
The Presbyterian Church in Alexandria was first organized in 1772 by a group of Scottish settlers, who built a sanctuary on this site. George Washington attended a service there in May 1778. The church was struck by lightning and burned down in 1835 and the present airy Greek Revival style building was erected over the following two years.

Christ Church (1773, 1818)
Cameron & N. Washington Streets, Alexandria
Built by John Carlyle, Christ Church is the oldest continually active Episcopalian church in the US. The tower, by James Wren, was added in 1818.

Page 88
US Air Force Memorial (1991–2006)
One Air Force Memorial Drive, Arlington, VA
The memorial was the last major work of architect James Ingo Freed (1932–2005) who also designed the US Holocaust Memorial Museum (page 36). The 8-foot high bronze honor guard statue is the work of sculptor Zenos Frudakis.

Ronald Reagan Washington National Airport (1941–97)
George Washington Memorial Parkway, VA
Built by the federal government, Washington's domestic airport was opened by President Franklin D. Roosevelt in 1941. In 2006 it served 18.5 million passengers. A major addition—including an airy new concourse and traffic control tower— was designed by Cesar Pelli & Associates with Washington's Leo A. Daly, and completed in 1997.

Page 89
The Pentagon (1943)
Arlington, VA
The massive headquarters of the US military—6.5 million square feet of floor space—was built in just 16 months from concrete using Potomac sand and gravel, and erected on what had been swampland. The Pentagon is regarded as a supremely efficient design in which no two offices are more than seven minutes walk apart.

Page 90
Dulles International Airport (1958–62)
Chantilly, VA
Dulles, which lies 26 miles west of the capital city, is one of the world's most architecturally and functionally significant airports. Designed by Finnish-born Eero Saarinen, the award-winning airport was opened by President John F. Kennedy in 1962. The soaring main terminal, with its gracefully curving roof hung between angled colonnades, has twice been expanded as the passenger load—which exceeded 27 million in 2005—has increased. These additions were designed by Skidmore, Owing and Merrill following Saarinen's original concept.

Detail from the stone lantern, page 30.

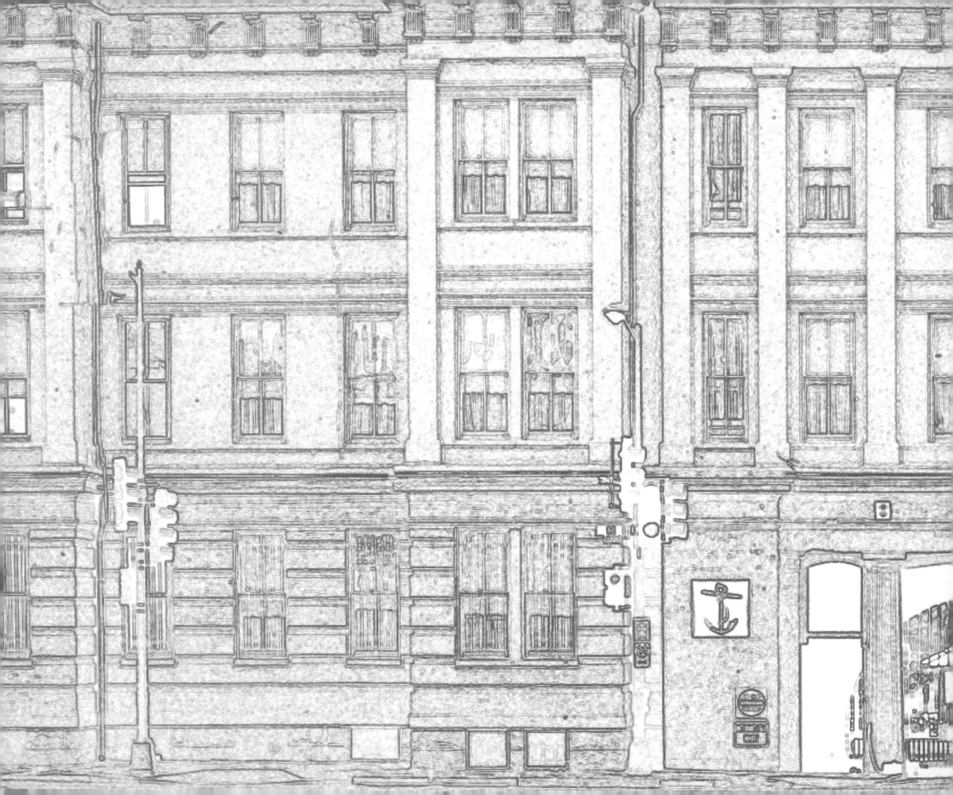